The Architecture of Collage
Marshall Brown

The Architecture of Collage
Marshall Brown

with contributions by

Anna Arabindan-Kesson
Aaron Betsky
Marshall Brown
James Glisson, Editor

Director's Foreword *Larry J. Feinberg*	7
Introduction *James Glisson*	8
Collage Is … Collage Ain't *Marshall Brown*	12
Chimera	15
Collage Architecture *Aaron Betsky*	40
Ziggurat	47
How to Build a Collage *Marshall Brown*	54
Maps of Berlin	57
Je est un autre	67
Notes from the Joint: Collage Ethics *Anna Arabindan-Kesson*	88
Prisons of Invention	93
Block, Procession, Spin, & Map *James Glisson*	114
List of Plates	120
Acknowledgments	123
Imprint	124

Director's Foreword

In 2021, the Santa Barbara Museum of Art celebrated its eightieth anniversary, completed the largest capital campaign in its history, and reopened its renovated, reinstalled, and enlarged galleries. All of those achievements were to further our mission, which is "to integrate art into the lives of people." In 2022, the museum delivered on that mission by embarking on an ambitious series of shows that began with an exhibition of works by Vincent van Gogh and ends with *The Architecture of Collage: Marshall Brown*, the first museum exhibition and catalogue solely focused on his collages. The museum is excited to sponsor this important exhibition and catalogue of Brown's work.

From its origins in the early twentieth century, collage has been a response to modern life in all of its complexities and contradictions. Moreover, throughout the past century, collage has linked different parts of the visual arts that capitalized on its mordant visual power to blast apart received ideas. Collage and its sculptural equivalent, assemblage, have indelibly marked artistic practices for a century, and both are well represented in the Santa Barbara Museum of Art's collection, with examples by Kurt Schwitters, László Moholy-Nagy, William Dole, Miriam Schapiro, and Nate Lewis, as well as Nancy and Ed Kienholz.

Brown's collages present architecture in a familiar yet strange form. Concatenations of modern buildings twirl and float. The history of modern architecture is presented as fragments. While these are made by a licensed architect, currently an associate professor at Princeton University School of Architecture, and fit within architecture's long-standing use of collage for presentation drawings, they ultimately ask bigger questions about the relationship between plan and building, or intention and outcome. On at least one occasion, Brown has used a collage to shape a built structure, yet the power of these collages is that they exist in a state of suspension in which possibilities can be weighed against one another without concern for practicalities, much less a finished building. These collages are exercises in the freedom of the imagination and achieve what contemporary art often does so well: suggest that the world could be different from what it is without specifying what that might concretely be.

This exhibition would not have been possible without the generosity of Susan D. Bowey; Barr Ferree Foundation Fund for Publications, Department of Art and Archaeology, Princeton University; Graham Foundation for Advanced Studies in the Fine Arts; The Museum Contemporaries of the Santa Barbara Museum of Art; and The Museum Collectors' Council of the Santa Barbara Museum of Art.

Larry J. Feinberg
Robert and Mercedes Eichholz Director and CEO
Santa Barbara Museum of Art

Introduction
James Glisson

Over the past ten years, Marshall Brown has developed a formidable collage practice, and this catalogue and accompanying exhibition seek to interpret and share that work with a larger, public audience. His collages pose questions about freedom and imagination, and how architecture might bring about the future. The utopia imagined in these collages, however, is not one of affordable housing, energy-efficient buildings, and certainly not the grand (and often ill-advised) urban redevelopment schemes of Robert Moses or Le Corbusier. Rather, it is akin to the murky one that Karl Marx once mentioned in passing in *The German Ideology* (1845), one of his few pronouncements about what a communist society might look like:

> [In a] communist society, where nobody has one exclusive sphere of activity but each can become accomplished in any branch he wishes, society regulates the general production and thus makes it possible for me to do one thing today and another tomorrow, to hunt in the morning, fish in the afternoon, rear cattle in the evening, criticize after dinner, just as I have a mind, without ever becoming hunter, fisherman, herdsman or critic.[1]

Marx's quote does not describe a particular outcome but conditions for nurturing talent and developing the full range of human ability. These collages are forums to practice design minus the constraints of budget, clients, or building codes, ways to think about buildings and architectural space outside of the circuits of production and consumption. Freedom might be doing something without an outcome because the doing of it is pleasurable and stimulates the mind. This version of freedom goes well beyond the confines of architecture, or even the arts and humanities, and hits the bedrock of human expression and fulfillment.

Because Brown's collages are a distinct strand in his practice, a little knowledge of his career is helpful to understand where they fit. Brown studied architecture at Harvard and later taught at the Illinois Institute of Technology, whose campus was designed by Ludwig Mies van der Rohe, an architect fond of collage. A licensed architect, Brown is currently Associate Professor of Architecture at Princeton University.

Brown has made a career out of proposing bold interventions to the urban fabric of American cities. With the encouragement of then New York City Council member Letitia James, Brown and a group of architects proposed an alternative to the Atlantic Yards development in Brooklyn. A few years later in his Smooth Growth Urbanism project, he had the simple but powerful idea to take the abandoned lots of Chicago's South Side and turn them into communal spaces. Another project, *The Center of the World: Histories of Chicago's Future* (2013), layers the center of Daniel Burnham's Plan for Chicago (1909)—today this point is at the I-90, I-94, and I-290 interchange, one of the busiest in the nation, near the former location of Oprah Winfrey's Harpo Studios, where the television personality filmed her eponymous show until 2011.

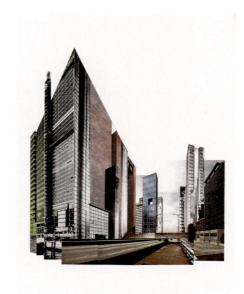

Holy City 3, 2013
Collage on inkjet print, 54 × 40 in.

Burnham represents the industrial Chicago of a century ago, a then-futuristic city brimming with factories processing the agricultural and mining resources of the American Midwest. Oprah, a trailblazing journalist, actress, and producer, stands for the new Chicago, with its entertainment- and finance-driven economy, but the African American billionaire is also a cultural phenomenon of extraordinary influence. Brown asks what will happen years from now if the former site of Harpo Studios becomes a place of pilgrimage to honor the life of Oprah and her legacy, and perhaps becomes a new locus for Chicago that recenters the city on the same spot identified by Burnham a century ago.

1 Karl Marx, *The German Ideology* (1845), https://www.marxists.org, accessed January 29, 2022.

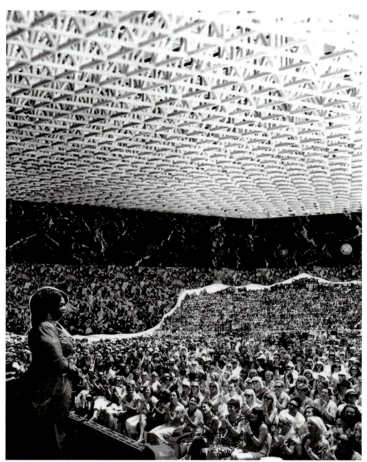
Still from *The Center of the World: Histories of Chicago's Future*, 2013
Looped digital animation, 14:47, edition of 5, 1 artist proof

Ludwig Mies van der Rohe, *Convention Hall Project, Chicago, Illinois (Preliminary version: interior perspective)*, 1954
Collage of cut-and-pasted reproductions, photograph, and paper on composition board, 33 × 48 in.
The Museum of Modern Art, New York, Mies van der Rohe Archive, gift of the architect, 572.1963
© 2022 Artists Rights Society (ARS), New York / VG Bild-Kunst, Bonn. Digital Image © The Museum of Modern Art / Licensed by SCALA / Art Resource, NY

With all of these projects, Brown made presentation drawings with collaged elements. They are all sited in places that are real, and there are constraints. Put differently, the built environment acts as a prompt that these begin with but soon take leave of. For example, *The Center of the World: Histories of Chicago's Future* shows tall buildings along the downtown freeway corridors, a familiar take on the city. The body of work in this catalogue rarely has any sense of a site or references to the natural world. Even the bits of recognizable buildings—Eero Saarinen's TWA Terminal, I. M. Pei's National Gallery of Art East Building—seem to stand alone in the world made by Brown. These collages can lead to realized projects (witness *Ziggurat*) but also serve as sketchbooks, repositories of forms and solutions for unknown projects in the future. These collages pull off the feat of being about building construction, space, and architectural design, yet without being tied down to means–ends rationality. This still-to-be-named new genre is the subject of the rest of this book. While these collages originate in architecture, their questions about meaning, spatial representation, and the correct role of art in society push them into a realm beyond the debates of architects and toward the role of art and aesthetics generally. Do not expect a simple answer. Freedom and imagination are about the quest and the experiment, not the plan, not the steps to follow, and surely not a predictable outcome.

One of the paradoxes of collage is that it is accessible and informal while also serving as a vehicle of searing social critique and reevaluation of what counts as art. It only requires scissors, glue, and the endless stream of printed paper that even in our digital age piles up on bookshelves, desks, mailboxes, thrift stores, and garages. One can even cheat and print images from the Internet. No easel, no paints, no brushes. Collage is forgiving of nicks, rips, bumps, and lumpy glue. A willingness to work hard to source images, an eye for arresting combinations, and voilà. A collagist is launched. These same factors can obscure the ambition and magnitude of what the medium can achieve as a political or aesthetic statement. Indeed, Pablo Picasso's and Georges Braque's experiments with collage a century ago blew up the mimetic traditions of Western art, while Hannah Höch attacked the mendacity of German politics in the 1920s and 1930s, and Romare Bearden chronicled the joys and tribulations of the Black experience in the United States. Similarly, when architects dreamed big across the twentieth century, particularly before CAD and computer animation, collage could provide the graphic zing to drive home a point or could make an image mordant, either in a client presentation drawing or reproduced for magazines and books. Indeed, some of the better-known architectural projects of the last century only exist as publications or drawings, sometimes with collaged parts—for example, Frank Lloyd Wright's Broadacre City, Superstudio's superstructures, or illustrations by Madelon Vriesendorp in Rem Koolhaas's *Delirious New York* (1978). Widely published and disseminated, these have stirred debate within and beyond the profession and seeped into the popular imagination.

With their twists, transformations, and wry titles (not to mention their manageable size), Brown's collages feel informal; yet, as the essays in this catalogue reveal, they also probe the history of modern architecture and methods of architectural design, challenging received notions about originality. Throughout the catalogue, Brown briefly introduces each collage series: *Chimera, Je est un autre*, and *Prisons of Invention*. He also talks about *Ziggurat*, which is (so far) the only built structure to come from the collages. In longer essays, he explains his working methods, his commitment to paper and scissors over the digital, and his concept of "creative miscegenation," which underpins the *Chimera* series. Additionally, there are essays by three contributors. Aaron Betsky, a widely published critic and historian of architecture, situates the work against the history of architectural collage and also speculates about veiled commentary suggested by some of the enigmatic titles, such as *The Staircase with Trophies* or *The Well*. Anna Arabindan-Kesson, an art historian who has written on diasporic art and blackness, considers the ethics of Brown's collages. She argues that these "architectural half-breeds," as she calls them, unseat ideas of authorship and purity, which, in turn, upset the racial hierarchies used to create a biased, restricted canon for visual art and architecture. For James Glisson, a curator of contemporary art, the collages bring into focus elemental aspects of how buildings are constructed, experienced, and mentally visualized.

Collage Is … Collage Ain't
Marshall Brown

Collage is a manner of creating, thinking, building, and understanding the world. Over the past decade, it has become my favored medium for actively engaging with and using my creative influences and to construct visions of the future. By sampling from the inherited material of architectural history, the production of space becomes an act of honorific thievery. As an *allographic* medium involving mechanical means of production that do not register a unique creator's hand, collage expands the antiquated definitions of authorship, originality, and novelty.[1] In his essay "The Ecstasy of Influence: A Plagiarism," the novelist Jonathan Lethem writes that collage "might be called *the* art form of the twentieth century, never mind the twenty-first."[2] Creation no longer belongs to the minds or hands of singular geniuses and has instead become the strategic synthesis of inherited material and ideas. Lethem explains that "inspiration could be called inhaling the memory of an act never experienced. Invention, it must be admitted, does not consist in creating out of void but out of chaos."[3] By "inhaling the memory" of architecture from across time and space, collage allows me to sample and recombine specific formal and material qualities to create new spaces that address new challenges in new contexts.

Collage is a transgressive act. By juxtaposing, remixing, and splicing images from disparate sources, collage can break aesthetic boundaries, expose false dichotomies, and challenge intellectual bigotries. An excellent example from popular culture is *The Grey Album* by DJ Danger Mouse.

Front cover of Danger Mouse, *The Grey Album*, 2004

In 2004 Danger Mouse created a mash-up of the Beatles' "White Album" and Jay-Z's *Black Album*. Danger Mouse's selection of these two sources was impeccable—matching the sacred "whiteness" of one of the Beatles' most acclaimed records with the profane "blackness" of one of hip-hop's greatest lyricists. We could compare it to Robert Smithson's experiment in entropy: the idea of a sandbox filled on one side with black sand and the other with white. A child walks around clockwise in a circle and then reverses the motion, but the entropic process only continues, blending ever further into gray. One can certainly hear the sources in *The Grey Album*, but they are both put in service of creating a new work of art that breaks cultural and creative boundaries.

Collage embraces multiplicities. I have previously written about collage as an act of creative miscegenation, which points to how collage destabilizes fixed notions of identity.[4] Every collage is a multitude in itself—both one and many. Throughout all of my work, the identities of individual fragments remain legible but matter less than their unions' productive potential. Over time, I have developed methods to cut architectural photography from journals, books, or enlarged photocopies and assemble the fragments by hand with tape and glue. Every collage incorporates at least three pieces from different sources. Because each image is carefully tailored to fit without overlaps, the collages possess a paradoxical visual quality. The seams produce the patchwork effect for which collage is known, but the alignments between images and figural contours of the composition conspire to create a visual synthesis. Thus, viewers experience visual tension between wholeness and fragmentation.

Collage reveals connections between conditions and concepts formerly thought separate. By appropriating found materials to create new works, collage disturbs our reality with defamiliarizations, disjunctions, and juxtapositions. These affordances are the consequences of physical actions: cutting, tearing, placement, and gluing. These movements become legible to viewers in the richly fractured surfaces of collages themselves as edges, overlaps, and seams.

In his book *Seamless: Digital Collage and Dirty Realism in Contemporary Architecture*, Jesús Vassallo observes that since photographers, filmmakers, graphic designers, architects, and artists use the same software, the technology and technique transfer "has intensified an existing trend, namely photography's gradual shift from being considered a discipline itself to a medium that is strategically co-opted by other disciplines within the larger field of art."[5] Vassallo writes in the last chapter of the book, "Because the union is impossible, the traditional collage becomes

[1] Allographic media are those that do not directly register the hand of unique creators in the ways that autographic media such as painting or drawing do. Because collage relies on appropriation of materials and images along with the use of mechanical reproduction methods, it is typically considered an allographic medium, much like printmaking and photography, for example.

[2] Jonathan Lethem, "The Ecstasy of Influence: A Plagiarism," *Harpers* (February 2007): 60.

[3] Lethem, "The Ecstasy of Influence," 61.

[4] Marshall Brown, "Creative Miscegenation in Architecture: A Theorem," in *Authorship: Discourse, a Series on Architecture*, ed. Monica Ponce de Leon (Princeton: Princeton University Press, 2019), 113–25.

[5] Jesús Vassallo, *Seamless: Digital Collage and Dirty Realism in Contemporary Architecture* (Zurich: Park Books, 2016), 171–72.

6 Vassallo, *Seamless*, 175.

7 As in the title of the recent book; see Andreas Beitin, Wolf Eiermann, and Brigitte Franzen, eds., *Mies van der Rohe: Montage=Collage* (London: Koenig Books, 2017).

8 To describe something as seamless is an apophasis—a negative statement that acknowledges certain contemporary phenomena by naming what cannot be said about them, as opposed to what can. Nonetheless, philosophy has long asserted that positive statements are more valuable than negative.

9 *Seamfulness* is a term attributed to the computer scientist Mark Weiser, who in the 1990s proposed the concept within the world of ubiquitous computing. According to Matthew Chalmers and Ian MacColl, in an address to the 1995 USENIX Conference, Weiser "suggests that making things seamless amounts to making everything the same, and he advocates *seamful* systems (with 'beautiful seams') as a goal. Paraphrasing Weiser's talk slides only slightly, and retaining his emphasis: making everything the same is easy; letting everything be *itself, with* other things, is hard." Matthew Chalmers and Ian MacColl, "Seamful and Seamless Design in Ubiquitous Computing," paper presented at the Workshop at the Crossroads: The Interaction of HCI and Systems Issues in UbiComp (2003).

a provocation, a disruption of the real. Digital collage on the other hand is seamless, concealing its own traces and thus merging portions of the real into a plausible alternative."[6]

Vassallo correctly observes that seams grant what he calls "traditional" collage its capacity to disrupt reality. After that point, however, is where Vassallo and I part ways. The word *collage* originates from the French *coller* (to glue). *Montage* also comes from the French *monter* (to mount or to affix). Together these terms circumscribe both the material and method by which collages are created. Indeed, the two words are often used to describe the same works, that is, montage or collage.[7] Paper cannot be uncut or unglued, so collage is a struggle of trials and errors. These errors and their unintended consequences are an essential source of collage's creative power. The same cannot be said of digital images, whose production requires substantially less risk, since every action can be undone immediately or in the future. Subsequently, I question whether a digitally composed image should carry the label *collage* at all, even if preceded by the word *digital*. Digital manipulations like those for which Vassallo advocates consist of pixels. When one zooms in closer to digital compositions, the hard edges between elements eventually dissolve, even at the highest resolutions. The seams in collages are minute but physically tangible, and they give collages a perceivable depth that digital images have never possessed and can only approximate at best.

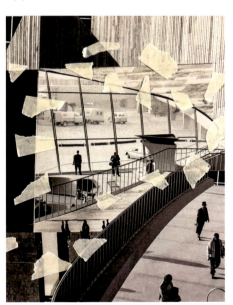

The Principle of Inconsistency, 2019
Collage under construction

As a material condition, seamlessness ironically undermines architecture's power to synthesize disparate conditions. As formal and spatial complexity increase in response to social and technological conditions, architecture will need more seams, not fewer. I still believe in the theory of medium specificity, which insists that the judgment should be based mainly on the degree to which it expresses and exploits the particular characteristics of its medium. Seamlessness has been a popular conceptual and aesthetic trope since the ubiquitous introduction of software to art and design from at least the 1990s.[8] Periods of cultural lag occur when societies struggle to comprehend the full implications of new technologies. One of cultural lag's most apparent symptoms is linguistic. In the absence of new language, we attach a modifier to something already known: digital drawing, digital modeling, digital collage, etc. The modifier—"digital"—implies that one is doing the same work or making similar artifacts as before, just faster or easier, for example. Such linguistic sleight of hand can effectively promote the adoption of new technologies, but it also delays the fundamental assessment of differences between legacy media and new media. Every medium has an intrinsic set of capabilities and limitations.

Seamlessness sidesteps the political imperative of distinguishing between creative methods. As an alternative conceptual framework, *seamfulness* would encourage us to actualize values by maintaining distinctions and strategically choosing some methods over others.[9] Though collage is a popular metaphor for all things heterogenous, I am arguing for clearer distinctions between what collage is and what collage is not. My motivations stem from concern for the politics of representation in art and architecture. Pious indifference to aesthetic, methodological, or cultural difference is a false cosmopolitanism that perversely undermines pluralism. Such ideological seamlessness only reduces our understanding of the world, much like the disintegration of over-enlarged screens into meaningless pixels. Seamfulness, on the other hand, implores us to embrace the challenge of articulating differences between what we are for and what we are against. Collage making and collage thinking have, for me, exposed seamlessness as a counterproductive architectural concept. Informed selection of media and methods produces radically different material results, formal propositions, and spatial conditions. All of these together, and in turn, represent distinct worldviews. Collage has been valued because it uniquely embraces complexity and uncertainty. Since collage always begins with selection, it also teaches us the necessity of making choices in an increasingly complicated world.

Chimera

These collages are three-bodied monsters, like their namesake lion-goat-dragon from classical mythology. They demonstrate the development of a rigorous method within my practice, whereby hand-cutting and -pasting of intricately shaped pieces conceal the seams between image fragments, creating new alignments between diverse and seemingly unrelated sources. The work presented here is just a selection from a much larger series, which was made precisely within one calendar year. These architectural constructions do not have predetermined locations or programs. Thus, each assemblage is an act of world-making. Except for the very earliest work in the series, the source material was a collection of inherited architecture journals from the 1980s to the near present. Just as twentieth-century collage was intended to shock, these Chimeras are designed to deceive, as architectural images are stealthily dismantled, realigned, and reassembled to create new forms and spaces.

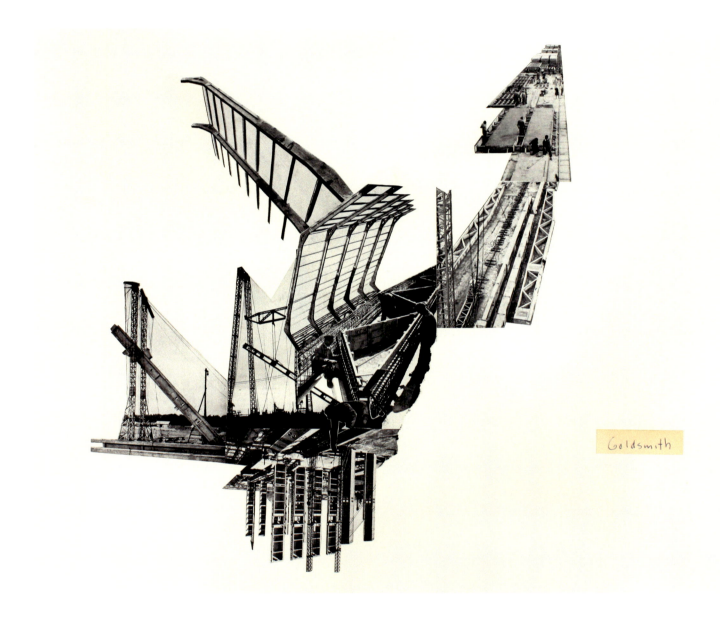

13-12-31, 2013
Collaged magazine pages, glue on archival paper, 14 × 17 in.
Santa Barbara Museum of Art
Museum purchase with funds provided by the General Art Acquisition Fund, 2022.8.6

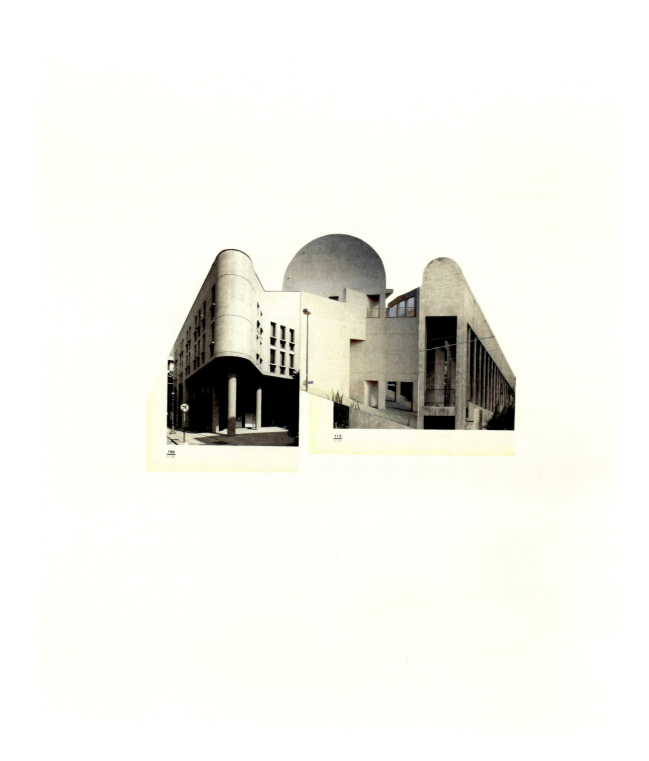

14-03-20, 2014
Collaged magazine pages, glue on archival paper, 17 × 14 in.
Collection of the University Club of Chicago, Chicago, IL

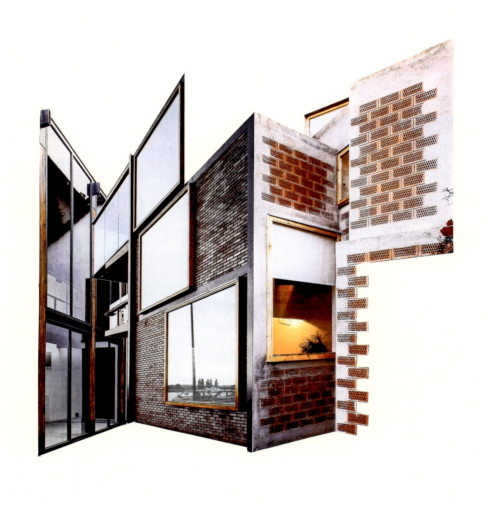

14-03-27, 2014
Collaged magazine pages, glue on archival paper, 17 × 14 in.

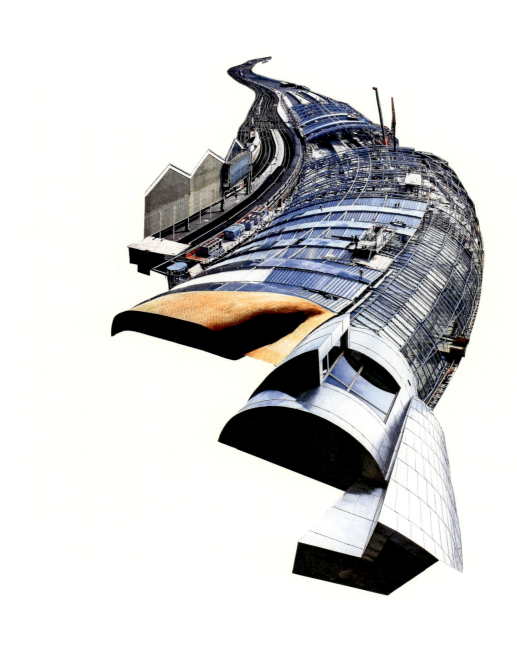

14-03-21, 2014
Collaged magazine pages, glue on archival paper, 17 × 14 in.

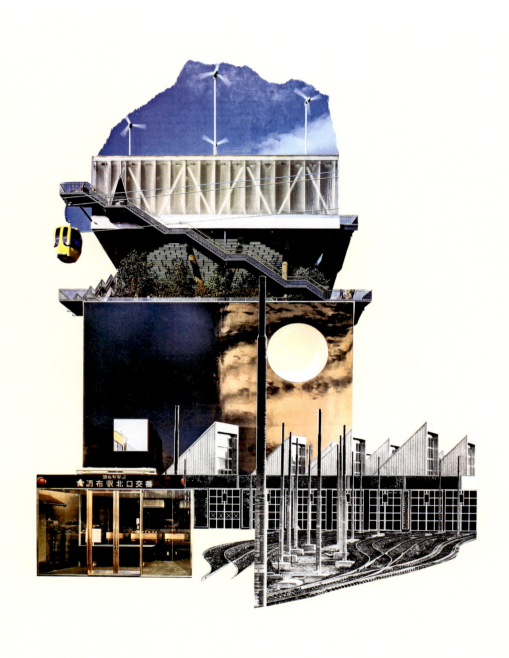

14-05-21, 2014
Collaged magazine pages, glue on archival paper, 17 × 14 in.

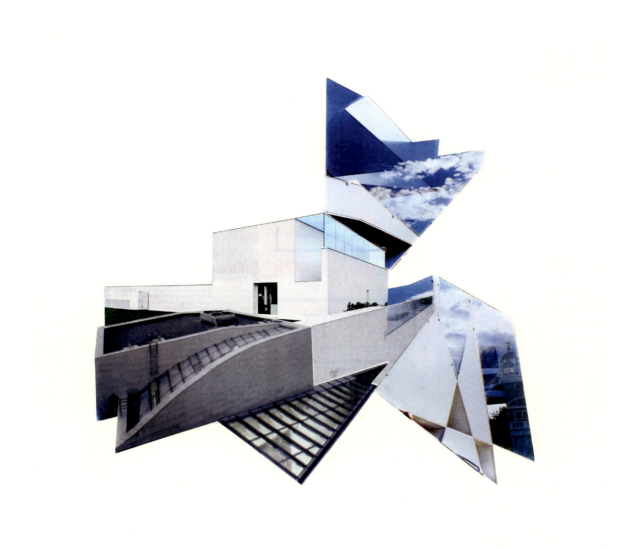

14-08-30, 2014
Collaged magazine pages, glue on archival paper, 17 × 14 in.

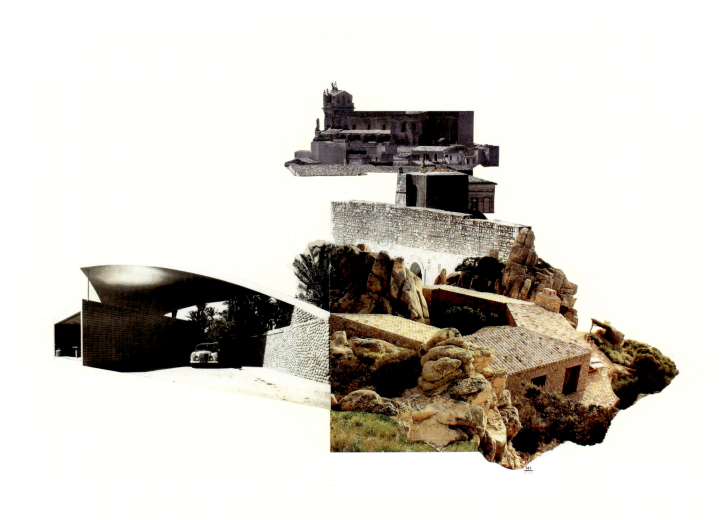

14-04-07, 2014
Collaged magazine pages, glue on archival paper, 14 × 17 in.

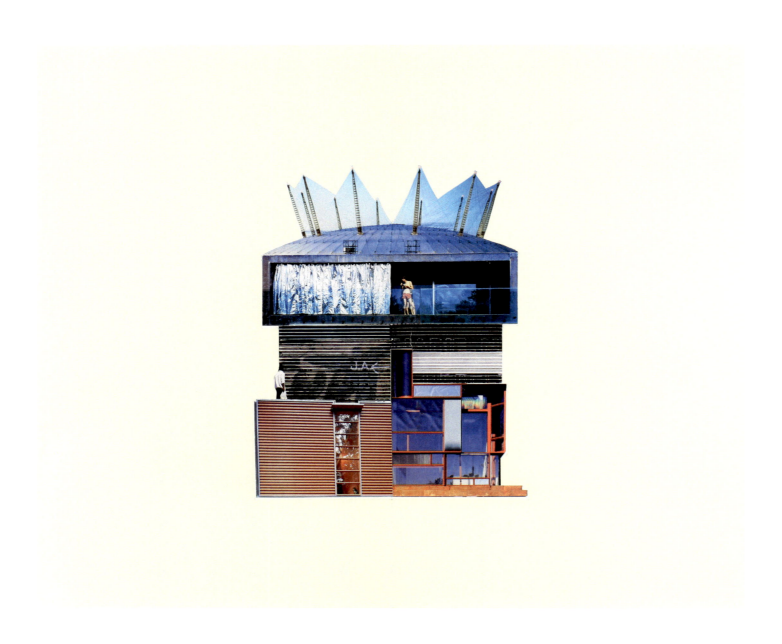

14-12-17 (2), 2014
Collaged magazine pages, glue on archival paper, 14 × 17 in.

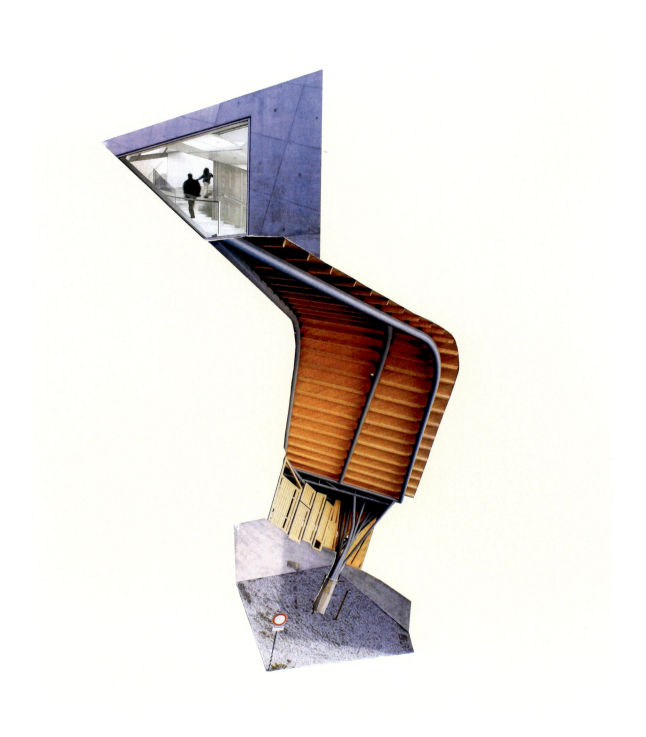

14-09-02, 2014
Collaged magazine pages, glue on archival paper, 17 × 14 in.

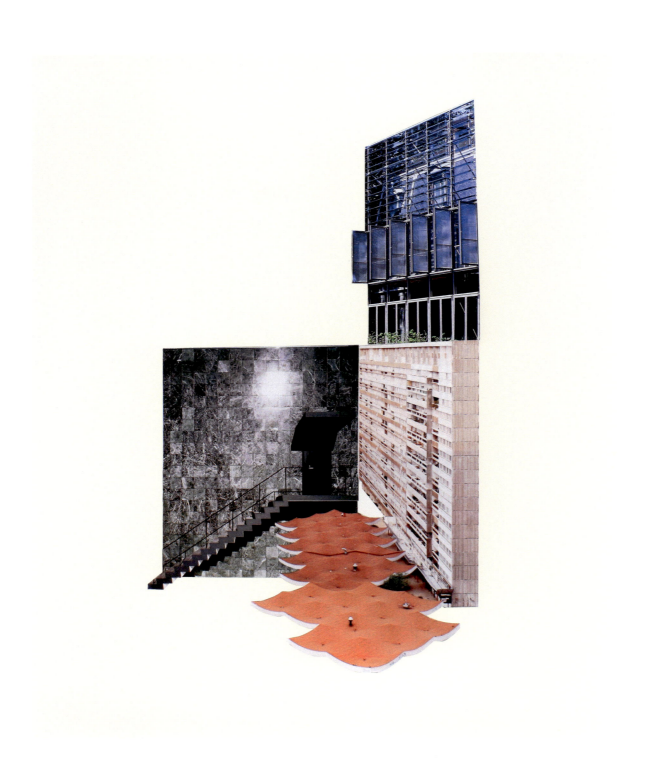

14-07-15, 2014
Collaged magazine pages, glue on archival paper, 17 × 14 in.

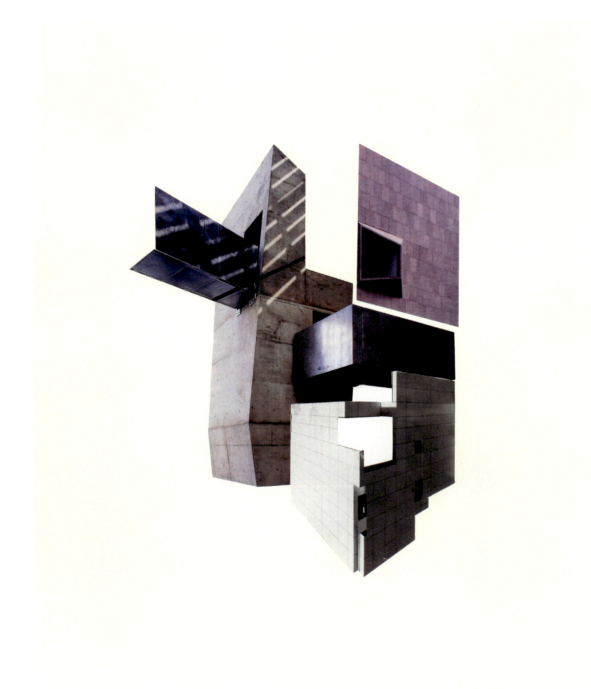

14-07-27, 2014
Collaged magazine pages, glue on archival paper, 17 × 14 in.
Museum of Contemporary Photography at Columbia College Chicago
Museum purchase, 2018:8

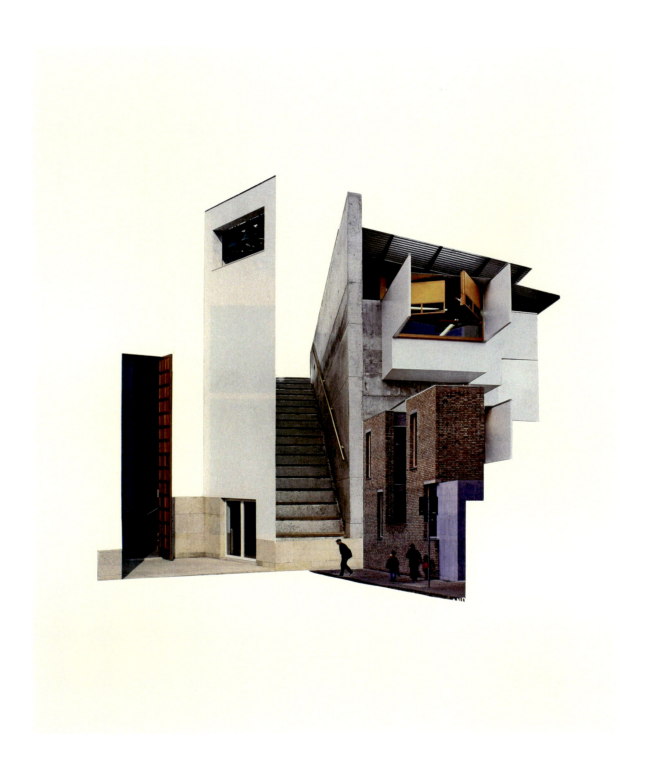

14-12-26 (3), 2014
Collaged magazine pages, glue on archival paper, 17 × 14 in.
Museum of Contemporary Photography at Columbia College Chicago
Gift of the artist and Western Exhibitions, Chicago, 2018:6

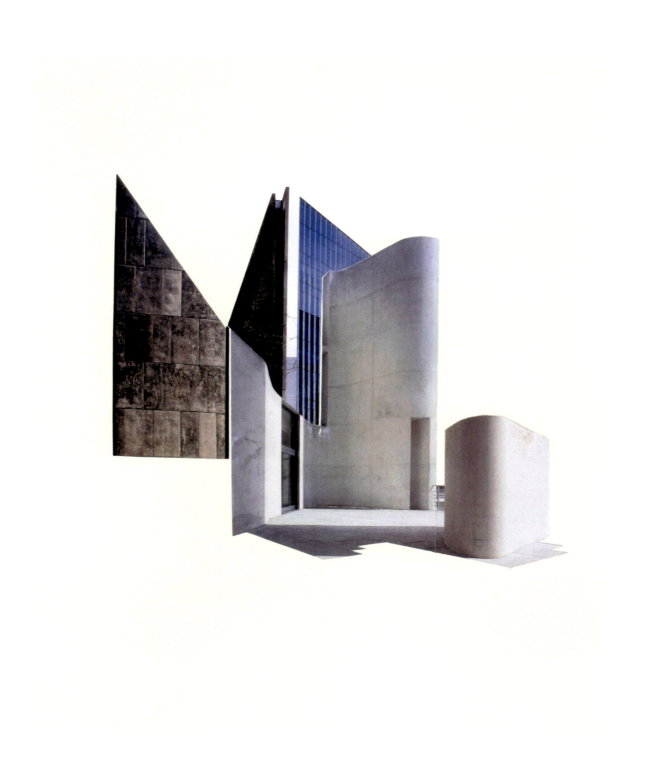

14-12-30, 2014
Collaged magazine pages, glue on archival paper, 17 × 14 in.

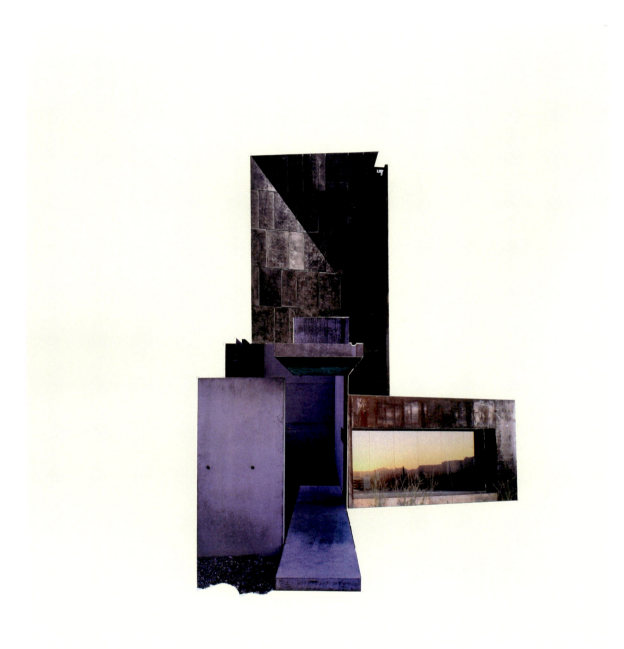

14-11-24, 2014
Collaged magazine pages, glue on archival paper, 17 × 14 in.
Santa Barbara Museum of Art
Museum purchase with funds provided by the General Art Acquisition Fund, 2022.8.4

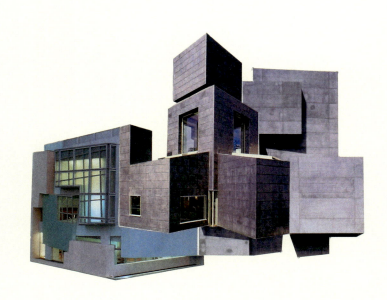

14-03-10, 2014
Collaged magazine pages, glue on archival paper, 17 × 14 in.
Collection of Conor O'Neil, Chicago, IL

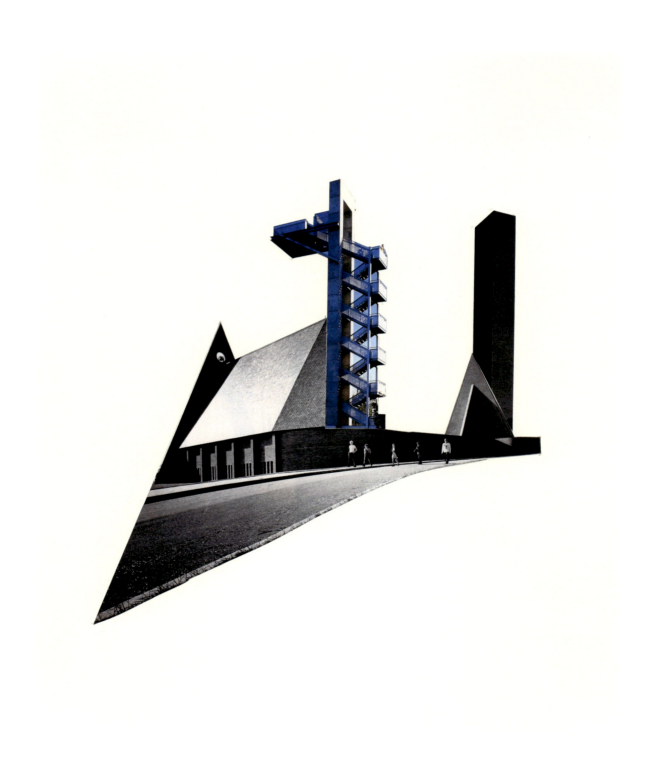

14-05-10, 2014
Collaged magazine pages, glue on archival paper, 17 × 14 in.
Museum of Contemporary Photography at Columbia College Chicago
Museum purchase, 2018:7

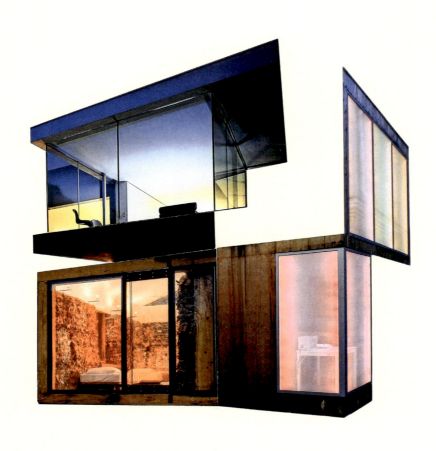

14-09-11, 2014
Collaged magazine pages, glue on archival paper, 17 × 14 in.
Collection of Suzette Bross, Chicago, IL

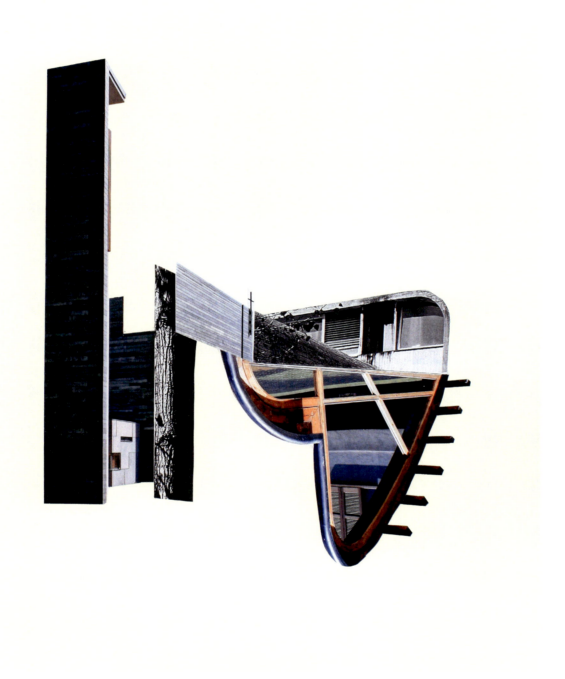

14-09-23, 2014
Collaged magazine pages, glue on archival paper, 17 × 14 in.
Santa Barbara Museum of Art
Museum purchase with funds provided by the General Art Acquisition Fund, 2022.8.5

Collage Architecture
Aaron Betsky

Marshall Brown has a peculiar notion of collage. Lined up with precision and limited in their derivation, his "found" images create not a collision of possible structures or intimations in a dreamworld without borders—in the manner we think of collages, in the classical, art historical sense.[1] Rather, they act as building blocks for architecture made out of curated images and forms orchestrated with the eye of an engineer of critical structures. They make analogous urban scenes, buildings that might not be possible, and structures that open up rather than enclose. They do this by showing rather than evoking that architecture. The buildings are present in the raw as actual found pieces, combined to make a composite form.

What Brown makes, in other words, are collages based as much on the peculiar needs, desires, and traditions of architecture as on the history of gathering disparate images and materials—a forceful part of art-making since the beginning of the twentieth century.[2] For Brown, the very fact that architecture is by necessity made of a variety of materials that comes together in a complex defined by a series of rules and structures (function, site, statics, and aesthetics, as well as the signifying imperative proper to images) is the reason to pursue his approach to collage. Like many other practitioners of what some call "paper" or "experimental" architecture, Brown is looking for ways to escape from the manner in which buildings, the anchor and supposed reason for architecture, are the constructed affirmation of the social, economic, and political status quo. To give architecture the freedom to be critical, other, and open, these architects want to build nonmaterial, nonfunctional, non-static, and non-site-bound structures. If some have recourse to the digital world while others draw on other art histories—such as the evocation of possible worlds, whether they are utopias or dystopias—Brown has chosen collage as his tool for the making of an unfinished and unfinishable architecture that nonetheless coheres.[3]

In addition to this theoretical standpoint, there is also the need that Brown and many in his generation feel to create architecture that does not deplete natural resources and opens itself up to as many different interpretations and uses as our culture has or should have. Such an open architecture is often nonmaterial, remaining an idea or projection. When constructed, the fact that it is made out of the remnants of daily life—unused or used-up materials that are upcycled—make it of necessity a kind of collage. Because of the nature of the found material, moreover, the memories and histories that cling to the images for a variety of nonprivileged users help to bring them home and to make a complex architecture open and present.[4] It is here that Brown's work intersects with recent experiments in the art world by the likes of Theaster Gates, Marjan Teeuwen, or Wangechi Mutu, to name just a few examples.[5]

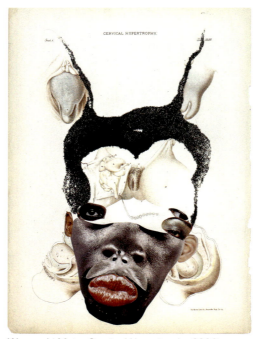

Wangechi Mutu, *Cervical Hypertrophy*, 2006
Collage on digital print, 23 × 17 in.
The Frances Young Tang Teaching Museum and Art Gallery at Skidmore College, New York
Gift of Michael Jenkins and Javier Romero, 2016.27.1
© Wangechi Mutu

Brown's approach to collage, in other words, is constructive rather than deconstructive. That does not mean that we can read his works as blueprints for the making of a three-dimensional building, even though he has made at least one such structure. Rather, it means the architect assembles and then aligns his work with a fair amount of care to come together into a coherent image in which each of the elements contributes to that overall sense of order. Though it does not mean that the many often contradictory associations and intimations that are native to most collage work in the classic tradition of the twentieth century are necessarily lost, these references are here restricted by both his reliance on architecture and urbanism as his source material and by his insistence on making sense of his material within the

1 For the classic summations of the history of collage in art, see John Elderfield, ed., *Essays on Assemblage* (New York: The Museum of Modern Art, 1992); Diane Waldman, *Collage, Assemblage, and the Found Object* (New York: Harry S. Abrams, 1992); or Christine Poggi, *In Defiance of Painting: Cubism, Futurism, and the Invention of Collage* (New Haven: Yale University Press, 1992), which is more narrowly focused. For a more recent survey, see Brandon Taylor, *Collage: The Making of Modern Art* (London: Thames & Hudson, 2006).

2 I am building here on previous work I have published on this subject, most notably in the catalogue of the Shenzhen-Hong Kong Bi-City Architecture Biennale 2015: Aaron Betsky, Alfredo Brillembourg, Hubert Klumpner, Doreen Heng Liu, and Gideon Fink Shapiro, eds., *Re-Living the City: UABB 2015 Catalogue* (Barcelona: ACTAR Publishers, 2015), 230–50.

3 Brown discusses his attitude toward collage in various interviews and lectures, such as one with the curator of the current project, James Glisson: "Collage Is … Collage Ain't." October 26, 2020, https://www.youtube.com/watch?v=KN-X7j2qG6A.

4 The argument for the integration of such social and environmental concerns with aesthetic strategies of collage in architecture and urbanism has been made most coherently by the architect Winy Maas, not only in his own work, but also through the publications of the Why Factory, his research lab at the Technical University of Delft. See especially Winy Maas and Felix Madrazo, eds., *Copy Paste* (Rotterdam: NAI 010 Publishers, 2017). The political aspects of this technique (again, in architecture and urbanism) were first articulated by Manfredo Tafuri in *Architecture and Utopia: Design and Capitalist Development*, trans. Barbara Luigia La Penta (Cambridge, MA: MIT Press, 1976), esp. 150–69.

5 Of these, Brown mentions only Mutu as an inspiration. Conversation with Marshall Brown, December 18, 2021.

framework of the image he produces. Moreover, his base material is a collection of photographs, not actual building elements, which makes them distinct from those collages that import the actual material and also makes their referential quality distinct.

Brown is resolutely an architect. His base material and his references remain on the whole within that field. His method of assembly limits itself to a logic that is proper to the field of buildings, namely the relationship between what the facade shows and the interior spaces and structural support it occludes. The play of architecture he creates is almost always the result of a misuse, distortion, or reversal of these elements.

Most of the images Brown uses are pieces of buildings that any self-respecting architect or architectural historian trained in the Western canon will recognize. Others are of less familiar urban scenes. Sometimes Brown uses those references to provide a site for the collages, giving us clues to identify them. In other compositions, he challenges us to recognize the source. This tension between easy-to-spot marquee buildings and others that sink into the banality of most of the built environment gives his work a foundation in the accepted elements of contemporary architecture but shows that field as less coherent, monolithic, or progressive than might be assumed.

The Well [p. 98] can stand as an example. Although there are two photographic fragments in his composition that are not strictly part of the realm of architecture—a couch, which we see from a skewed top view, and a pile of rocks, the dominant effect is that of a perspective view toward a concrete wall. The window frames with angled horizontal louvers hide the actual panes of glass we assume are behind the structure. The facade angles and is intersected by a wall of bricks set in a concrete frame. These two elements, which support each other visually, are connected by another fragment, also of concrete, which appears from this angle to be a bridge. They both sit on the pile of reddish rocks, but below that apparently solid ground, which heaps over the upturned couch, another vista opens. An X shape made up of a cut in the photograph and an angled, refracted sunbeam slanting down a wall of concrete, which is mirrored and reversed in the assembly, dominate the bottom of the picture. The space receives further importance because of a lozenge-shaped fragment Brown has keyed into the intersection of the V-shaped cut and the change in the angle of light.

What *The Well* adds up to is, I believe, a narrative. It gives us the revelation of a subterranean place of light and abstraction that evokes such places as Peter Zumthor's thermal baths in Vals, Switzerland, a perennial pilgrimage destination for architects, a place filled with aura. Grids appear to be references to the work of Le Corbusier and an anonymous building photographed by Bas Princen. It is not too far-fetched to imagine an even more direct reading of the image: the architect, dreaming on the couch, tumbles into a well of light and space hidden below these canonical examples of architecture. A small sign on the concrete wall reads "members" and reinforces the sense that Brown is escaping into a world of free architecture, hidden behind the facades of heroic buildings from which he might otherwise be excluded.

Brown, in other words, hints at allegory and commentary in a way that is rather forceful. These two terms have been part of how Surrealists and artists like John Heartfield used collage. The medium has often taken on a political meaning, as in Heartfield, or attempts to show psychological principles, like the unconscious for Surrealists like André Breton or Max Ernst. Yet there is something more definite and straightforward to Brown's work than these earlier examples. This is because he stays within the realm of architecture. What he is doing follows a line of development that runs from Le Corbusier's neo-Purist collages through the work of the artist and world-maker Constant (Constant Nieuwenhuys), the Italian collectives Superstudio and Archizoom, the British magazine-making group Archigram, and the early collages Madelon Vriesendorp created as part of the Office for Metropolitan Architecture (OMA), which helped illustrate the texts produced by her then-husband, the architect Rem Koolhaas, to a generation of architects using digital manipulation, such as Hani Rashid or Filip Dujardin (whom Brown cites as an inspiration), working with the computer's ability to resolve all complexity and contradiction into smooth space and form.[6] These architects construct a scene, place figures in a more or less believable space, and present the result as an alternate reality, whether it be utopian, dystopian, or allegorical. Brown continues this tradition without the overall sweep evident in that older work but with, instead, a conscious nostalgia for those collage visions of possible worlds.

The critic and historian who most clearly articulated this idea of collage as evoking another world in architecture was Colin Rowe in *Collage City* (1978), written in collaboration with Fred Koetter. The book called for understanding the urban environment as producing, through its own organic forces, a continually evolving collage. Rather than making sense of this "messy vitality" (to quote another lover of collage architecture Robert Venturi) by wiping out the seeming contradictions and imposing

grids on top of the urban coagulation, they suggest that architects work in the manner of curators, assembling a virtual museum of elements that then, in a deliberately mixed metaphor, could act as a scaffolding on which future urban life could flourish. They argue the result would be

> a two-way commerce [...] between the fabric of the museum and its contents, a commerce in which both components retain an identity enriched by intercourse, in which their respective roles are continuously transposed, in which the focus of illusion is in constant fluctuation [*sic*] with the axis of reality.[7]

Rowe and Koetter's book helped justify (or produce) some of the more eclectic assemblies of the Postmodern movement, combining with Charles Jencks's insistence on architecture as a form of semiotics to produce a recipe for buildings that would, in an ordered and deliberate manner, evoke a variety of different traditions and arrange them as building blocks for a multicultural but highly organized urban setting.[8]

It is perhaps no wonder then that Brown disavows *Collage City* and Rowe's writing in general as an influence, claiming to have been experimenting with such techniques long before he heard of the text. If there is a relation to Rowe's writing, we can assume it was indirect, and most probably through the presence of Koolhaas (who had studied with Rowe) and many of his associates and disciples at Harvard, where Brown did his graduate work.[9]

Whether or not there was a direct connection, it is evident that Brown has chosen a particular approach to the making of collage that distinguishes it from most contemporary explorations of that technique in the field of architecture and aligns it with a distinct tradition in architecture. What he brings to that work is a distinct sense of clarity and order, as well as a critical message and wry sensibility. It is, in other words, not a form of overt criticism or a dreamworld, as it has often been in art, nor is it a vision of a complete world. Rather, it is, as Rowe and Koetter had called for, a kind of scaffolding and museum of found images that constructs fragments of an urban scene.

Those attributes are certainly on display in the assemblage that is the one built version of his photo-based work, *Ziggurat* [p. 47]. Originally displayed in Chicago outside a small members-only club, this aluminum foam structure is a direct commentary on and reassembly of a house design by another hero of modern architecture Frank Gehry, mixed with less evident references to works by Peter Eisenman and Zaha Hadid. Gehry's structure, the Schnabel House (1989), is built around the "X marks the spot" strategy so evident in *The Well*.

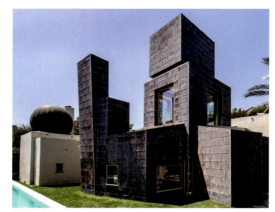

Frank Gehry, The Schnabel House, Los Angeles, 1989
Photo (cropped): Marc Angeles

A central fireplace rises through the middle of the structure, surrounded by a second skin Gehry punctured to allow light to wash down the solid volume. The rooms of the house radiate out from this occupied center at angles, gesturing toward the landscape while anchoring themselves around the vertical core.

In Brown's version, the tower stands at the intersection of planes and blocks that evoke not only Gehry's building, but also the masses of the skyscrapers and the club around the building, pried away from their functional and structural logic to become an essential version of construction. A window with no front or back angling out from the core construction further emphasizes the critique of the coherence of building hierarchies, while the whole also teeters on top of I beams that you would otherwise expect to be buried during the construction of a "real" building. *Ziggurat* evokes solidity and monumentality even in its name, and then denies those qualities in its composition and materiality (as it is made out of stabilized aluminum foam that looks like stone), emphasizing its role as critique or persiflage of the pompous, business-dominated grids of Chicago.

In many of Brown's works, however, criticism gives way to speculation and even a dreamlike evocation of an architecture that cannot exist. Whether that impossibility is the result of a lack of commissions, a defiance of the rules of gravity and use, or the inability to even conceive of a building that could be as beautiful and as effective as the ones the architect can produce in collages is a question I cannot answer. In his more recent *The Gothic Arch* [p. 104], for instance, a staircase leads from the bottom of the image through another structure of brick and concrete. As the treads turn by a column, that latter brick form rises up into a concrete arch fragment, which then

7 Colin Rowe and Fred Koetter, *Collage City* (Cambridge, MA: The MIT Press, 1978), 137.

8 Charles Jencks, *The Language of Post-Modern Architecture* (London: Academy Editions, 1977).

9 Koolhaas's attitude toward collage has been to integrate its forms into seamless architecture, using it to elide what should be, for instance, the division between floors, ceilings, and walls, or by creating stacks of different program elements, each with their disparate manner of appearance. See for instance his Kunsthal in Rotterdam of 1992, or his more recent renovation of and addition to the Prada Foundation in Milan (2017–19).

sweeps off toward the top of the image as a knife of light cutting across a wall whose brick elements are much smoother than those in the bottom fragment. Along the way, the arch curves by a reversed image of a reddish wall, punctured by openings into white abstraction. A white car clings to the pavement that is now a ceiling, while blue tape fragments that sew these pieces together then either fall through the images or rise up toward the sky.

This is an aspirational work, moving from the clarity and solidity of the base with its solid pieces of buildings to a gesture toward pure abstraction at the top that moves in space past the tape and the car as well as the structures that make it possible. It seeks, more than some of the others, to move up toward some planned resolution in the manner of an annunciation or resurrection. Perspective draws us in, structure situates us, and then perspective releases us, and the cuts mark out a journey into a possible architecture.

Not all of Brown's works have this kind of solemnity. Many of them have an explosive character, enticing us, as in the image of the interior of Frank Lloyd Wright's Guggenheim Museum in 2020's *Pantheon* [p. 95], for instance, into a whirlwind of imagery before spitting us out into the corners with a fragment of a truss that just happens to form an arrow pointing to the lower left-hand corner, or a curving staircase tumbling upside down toward a petal-shaped image of a curved window frame. What if the motion of Wright's continuous ramp could continue through and past the building, and involve, distort, and fling apart the structure, the walls, the windows, and every other element of what we think makes up a building? This is the question Brown is asking here. The answer is that it is possible in the collage.

In other cases, such as *The Grand Piazza* [p. 105], Brown is less optimistic. A fragment of a domed building with a ramp looping across and into it, set against a gray sky while minuscule people gather at the base of this spaceship, hovers above another of Brown's concrete walls, here almost solid except for a pattern of slits. A photograph of a parking lot Zaha Hadid designed as part of a multimodal transit station in Strasbourg is the upside-down element in this composition and closes off the image further. The gestures dead-end here, precluding entry or even imagination in favor of a texture that is all gray, all closed, all organized as blocks of occlusion sitting squarely on the page.

Brown can also be directly critical, as when he shows fragments of Zaha Hadid's Rosenthal Center for Contemporary Art in Cincinnati with a lone African figure standing at the end of a long edge and a fragment of a mural by

Le Corbusier pasted above it. Called *The Staircase with Trophies* [p. 99], the construction calls for us to bust open the tombs in which we inter art and artifacts, in particular the work of other cultures, while evoking how we might do that by specifically quoting the history of collage within architecture.

While most of the work Brown has created until now (and I speak here only of his efforts in this mode, not of either his designs for buildings and urban projects or his community engagement activities) stays within the realm of borrowed fragments of architecture, he has also explored ways to evoke urban environments that are more abstract. His *Berlin Storyboard*, for instance, eschews the assembly of pieces cut and spliced to fit together in favor of a linear sequence of black-and-white photographs of that city.

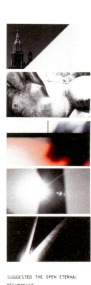

Marshall Brown, *Berlin Storyboard*, 2021
Digital photographic prints, glue on paper,
each board 14 × 10¼ in.

Some are recognizable, including a panoramic view of the former East Berlin or fragments of structures built in the postwar era, as well as a sculpture of a Nazi eagle and a skull, but others are close-up views of everything from building elements to sculptures. Brown punctures the storyboard with sentence fragments, most of which evoke issues of power and an attempt to escape from its clutches:

> "Where the whole notion of the master war or political. … Commitment to the memory to open the future. … The option of erasing other urban centers … I am working patterns and building the texture. The area an urban room that has remained untameable [*sic*] …" before ending with "Finality a Dream."[10]

It would be easy to read the project as Brown's manifesto, especially as he also speaks of "a knot between time and space seen as a form," but I would be reluctant to take the words at more face value than the images this architect so consistently reverses in both placement and meaning. Rather, these are musings, I believe, fragments of thoughts that are readable in multiple ways. They all twirl around the question of whether architecture can address issues of power and its construction in buildings and art by gathering not what exists but images of what exist, and then reordering them toward a dream of how architecture can escape from its bounds.

Unlike most visual artists working in collage, but like most architects who have availed themselves of that medium, Marshall Brown thus gives us a clear idea of what he wants to build with his work while remaining within the realm of presentation drawings, blueprints, and other modes of architectural representation. He is resolutely acting as an architect, proposing a building, even if it is present purely as a collage image and thus remains notional. The collages are the equivalent of plans, sections, presentation models, and perspectives, but shorn of their ultimate purpose and thus sufficient in themselves. That does not mean, however, that Brown precludes interpretation or speculation. He welcomes the fact that his collages, by not working to propose buildings, welcome many possible outcomes and uses, even if only in the way we process them in viewing. Certainly, the way I have given particular meanings to the examples cited above is itself open to critique. That is the one beauty of collage that Brown's directed approach does not slither away from: exactly because the fragments come with their own memories and realities, and because their assembly will, despite the order this architect applies to their construction, never be hierarchical and definite, they always remain open-ended. You can always do more with Marshall Brown's work.

Indeed, we can just enjoy Marshall Brown's collages for what they are: architecture that has no need of pouring concrete, mining iron ore, running air conditioners, or enclosing us in functional cages. Instead, it is architecture that frees us to think about where we have come from, where we are today, and where we might go on the wings of possible architecture.

10 Marshall Brown, *Berlin Storyboard*, 2021, n. p.

Ziggurat

Ziggurat is a contemporary interpretation of the small pleasure pavilions or follies that can be traced back to eighteenth-century European gardens. The artwork draws from a collage in the *Chimera* series [p. 15]. For *Ziggurat*, architectural masterworks by Frank Gehry, Peter Eisenman, and Zaha Hadid are sampled and carefully recombined within a collage that inspires an entirely new construction. The structure is clad in Alusion, a stabilized aluminum foam panel, which was chosen for being metal but having the texture and appearance of stone. This project was initially commissioned by the Arts Club of Chicago and was funded in part by the generous support of the Chauncey and Marion Deering McCormick Foundation. *Ziggurat* is now in the permanent collection of the Crystal Bridges Museum of American Art, Bentonville, Arkansas.

Ziggurat, 2016
Alusion foamed aluminum panels, wood structure
and aluminum I beam base, 122 × 144 × 96 in.
Crystal Bridges Museum of American Art, Bentonville, AR
Made possible by Chauncey and Marion Deering
McCormick Foundation, 2018.14

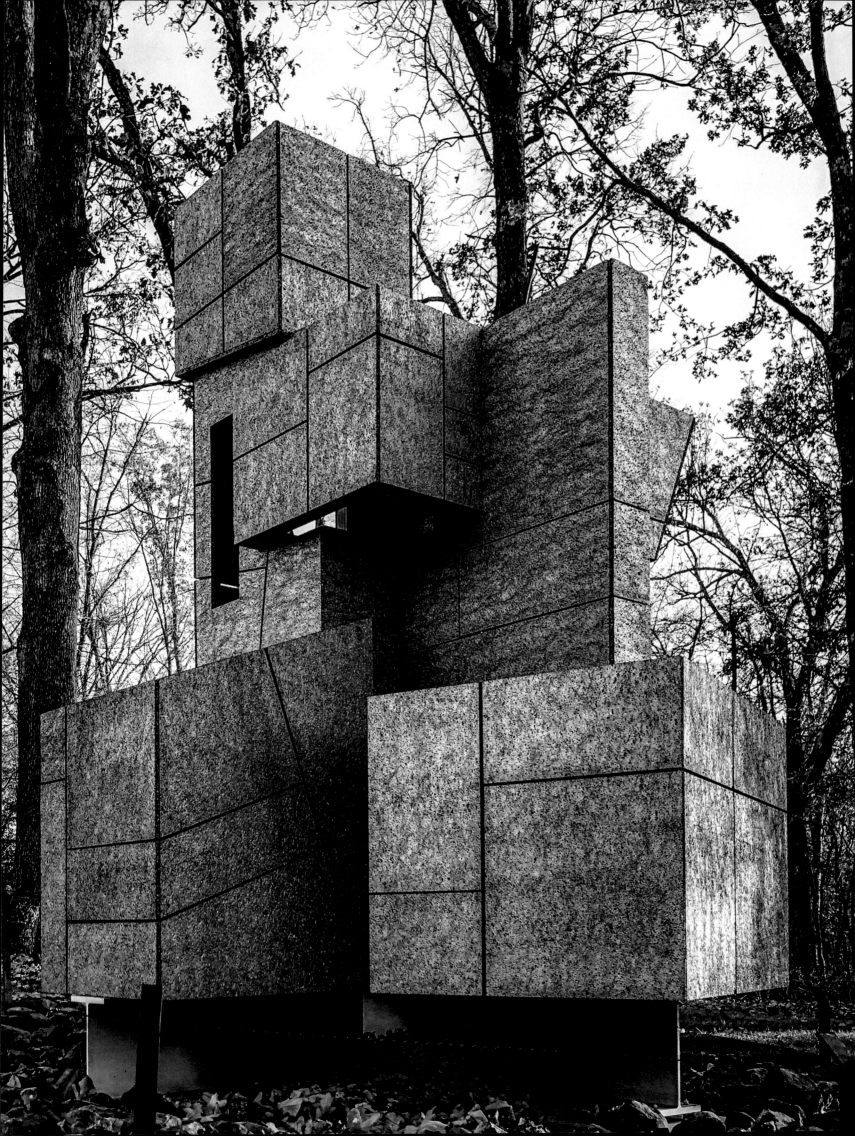

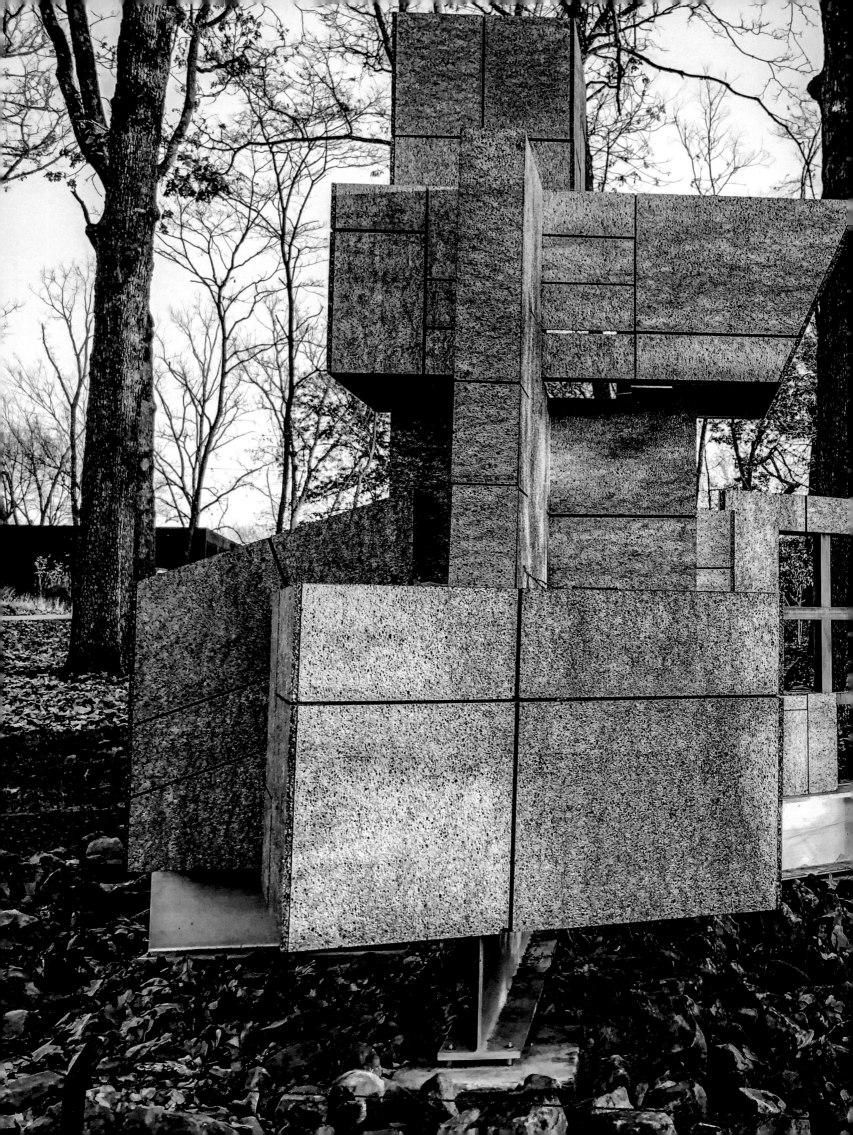

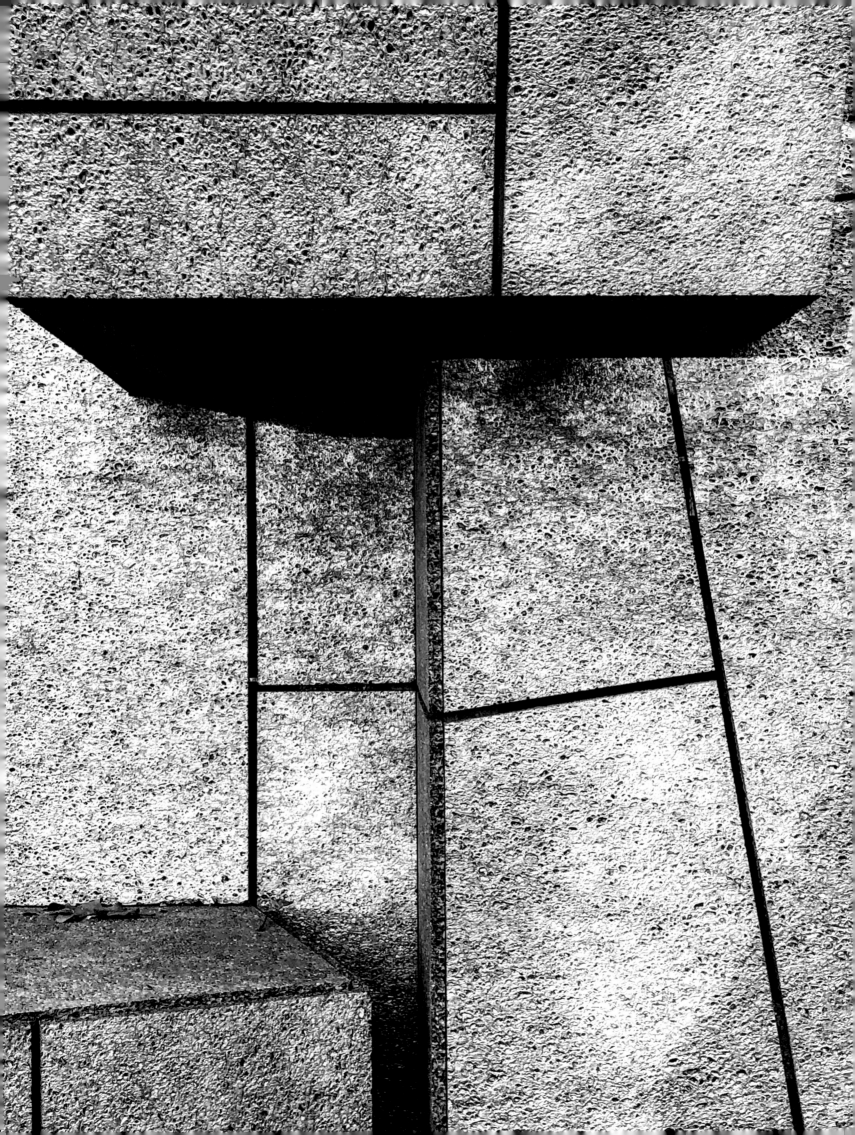

How to Build a Collage
Marshall Brown

Collage remains an unconventional form of architectural representation despite its consistent and often conspicuous presence since the beginning of modernism. Collage was formative in the work of Ludwig Mies van der Rohe, Eileen Gray, Superstudio, Rem Koolhaas, Craig Hodgetts, Carme Pinós, Enric Miralles, and many others. From the beginning, my practice has also been engaged in a productive struggle with collage. To my frustration, architectural literature has relatively little to say about collage's methods, its possible conventions, or its instrumental value in the production of architecture.[1] Collage leverages indeterminacy and is highly effective in the critical moments when concepts and forms first take shape.

In 2016, I chose a single collage from my production as source material for *Ziggurat*, a garden folly for the Arts Club of Chicago.

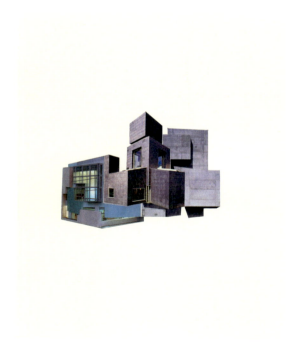

14-03-10, 2014
Collaged magazine pages, glue on archival paper, 17 × 14 in.
Collection of Conor O'Neil, Chicago, IL

The referent collage fuses elements from Peter Eisenman's Koizumi Sangyo Corporation Headquarters, Frank Gehry's Schnabel House, and Zaha Hadid's Rosenthal Center for Contemporary Art. From concept through construction, *Ziggurat* is a demonstration of collage as a generative technique, as well as a conceptual framework in architecture. The source collage came from the *Chimera* series. All of the artworks in this series are composed of architectural photographs hand-cut directly from architectural journals and then glued. While the *Ziggurat* came from one collage, the Chimera are autonomous exercises free from the usual constraints of architecture. Each collage from the series incorporates a minimum of three image fragments cut from photographs of different buildings. Pieces never overlap, which necessitates the search for alignments and an obsessive construction of seams. The edges of every fragment are carefully designed and cut to fit with their intended counterparts, like pieces of reverse-engineered puzzles. The identity of the architectural samples matters less than their potential for productive unions. Collages made this way produce a double reading. Because of variations in coloration, scale, or viewpoint, the heterogeneous effect of collage is still strongly present. However, the alignments and seams work together to create a disorienting visual tension between fragmentation and synthesis. Like the mythical lion-goat-dragon for which they are named, the Chimeras are both one and many.

Unlike other uses of collage in architecture that emphasize disjunction, collision, or quotation, my practice uses it to synthesize disparate elements into new architectural wholes. Elsewhere I have articulated a *theorem of creative miscegenation*, which states that *the legibility of architectural configurations is engendered by their promiscuous associations among a generalized discursive field*.[2] A work of architecture cannot be understood outside the broader field of which it is a part, and the work is not constrained by its precedents but instead creates a new set of relations between them and itself.

Turning a flat collage into a freestanding structure requires several translations. The first is scalar. *Ziggurat* needed to be as large as possible but still fit within a narrow garden site, resulting in a structure approximately ten feet tall and twelve feet in diameter. *Ziggurat* is not large, but still somehow cuts a monumental figure, thus pointing to the second translation—from a two-dimensional composition to a three-dimensional form. Whatever architecture we imagine existing behind the collage must be discovered by extrapolation or inference. For *Ziggurat*, this is accomplished by moving directly from collage to model. The drawings serve only for developing the surface articulations and as instructions for the fabricators, which leads to the third and final translation into a material manifestation and method of construction.

1 The most notable exception is an essay by Ben Nicholson, "Collage Making," in *Appliance House* (Chicago: Chicago Institute for Architecture and Urbanism, 1990). Only very recently has there been a spate of books on collage in architecture, including Martino Stierli, *Montage and the Metropolis* (New Haven: Yale University Press, 2019); Andreas Beitin, Wolf Eiermann, and Brigitte Franzen, eds., *Mies van der Rohe: Montage=Collage* (London: Koenig Books, 2017); Craig Buckley, *Graphic Assembly: Montage, Media, and Experimental Architecture in the 1960s* (Minneapolis: University of Minnesota Press, 2018); and Jennifer A. E. Shields, *Collage and Architecture* (London: Routledge, 2013).

2 For a further articulation of the theorem of creative miscegenation, see Marshall Brown, "Creative Miscegenation in Architecture: A Theorem," in *Authorship: Discourse, a Series on Architecture*, ed. Monica Ponce de Leon (Princeton: Princeton University Press, 2019), 113–25.

3 *Ziggurat* was engineered, fabricated, and installed by Navillus Woodworks of Chicago.

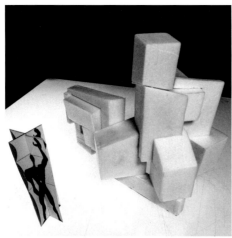

Model for *Ziggurat*, 2016

One might expect this building to employ a mix of materials chosen from its referents, given that it springs from a collage. Instead, the sources are subsumed by deploying one surface material throughout the entire built form. Although the referent buildings are still recognizable within the collage, *Ziggurat*'s continuous aluminum cladding unifies the built assemblage as an independent architectural identity. One-half-inch-thick aluminum foam panels are supported by framing secured to an aluminum I beam foundation. Of course, this building, like any other, negotiates the circumstances of its site, economics, and construction with higher conceptual and aesthetic aspirations. The aluminum foam provides lightness and durability, but more importantly, its expression (for lack of a better term) oscillates between artificial and natural.

One-half-inch open joints run continuously around the corners, paradoxically unifying the panels into volumes. The rough and porous surfaces begin to resemble stone blocks, making *Ziggurat* appear deceptively massive. The articulation of seams critically informs the structural design and construction process as well.[3] Since the original commission was a temporary installation, the design is segmented into eight structurally independent sections that allowed for quick demounting at the original site in Chicago and easy reassembly at its current home, the Crystal Bridges Museum of American Art.

Architecture and collage are both fundamentally charged with fusing disparate elements into cohesive figures. In both cases, this alchemy is produced through the manipulation of seams. The seams created between two pieces of paper in a collage are not lines but gaps. If one magnifies a collage, the seams become fissures. Seams create the space for conceptual connections by holding entirely unrelated things ever so slightly apart. Architects should be uniquely able to recognize the significance of seams, since collage making is analogous to the assemblage of architecture itself. Architectural seams allow us to assemble aluminum panels, I beams, wood, and bolts into something significantly more than the collected parts. Collage, though a two-dimensional medium, works similarly with images, paper, and glue. As architectonics is an art of joining, so is collage.

Maps of Berlin

Urban plans project order by abstracting urban reality. The dynamics of history, politics, economy, and culture are frozen and reduced to surface traces of streets, buildings, landscapes, and place names. Despite their thematic reductivism and all they are unable to represent, the precision and beauty of maps reassure us that we know enough to continue building in the face of constant uncertainty. Recalling Giovanni Battista Piranesi's map of the Campus Martius (1762) and map of Rome, created with Giambattista Nolli (1748), these maps of Berlin exist at the intersection of reality and uncertainty, portraying cities that could have been or others that might yet be. The source material is a series of technical documents titled *Die Städtebauliche Entwicklung Berlins von 1650 bis heute* (The Urban Development of Berlin from 1650 to Today). The series was created by the Berlin Senate Department for Urban Development and Environmental Protection in 1986, shortly before the city's reunification.

Piranesian Map of Berlin, ca. 1800–1690, 2022
Collage on gessoed board, 96 × 72 in.

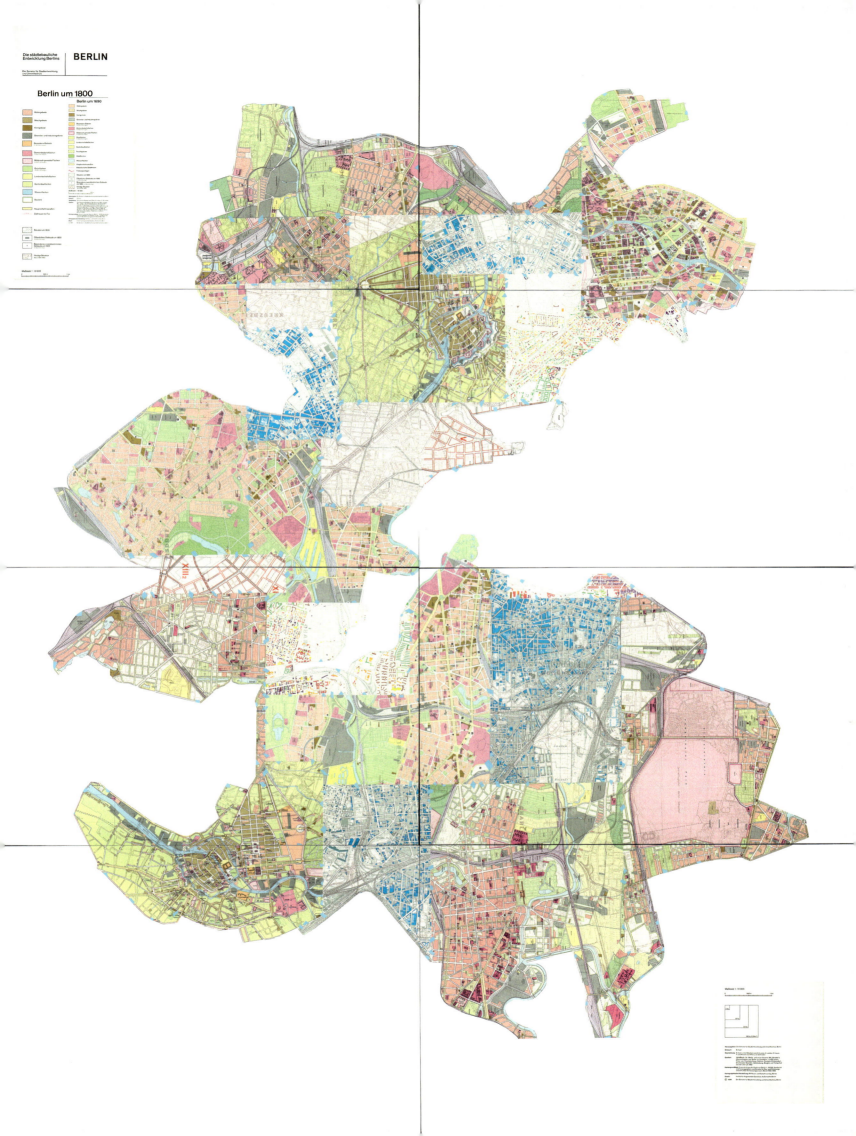

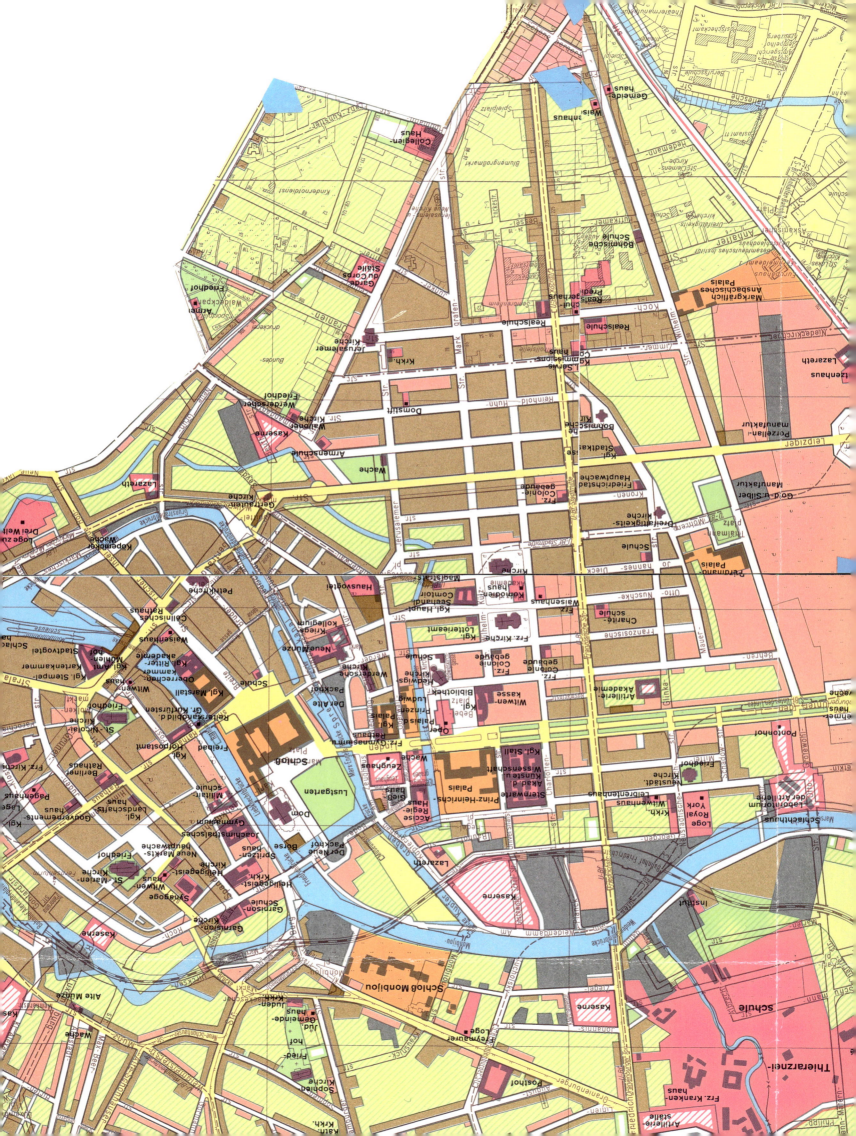

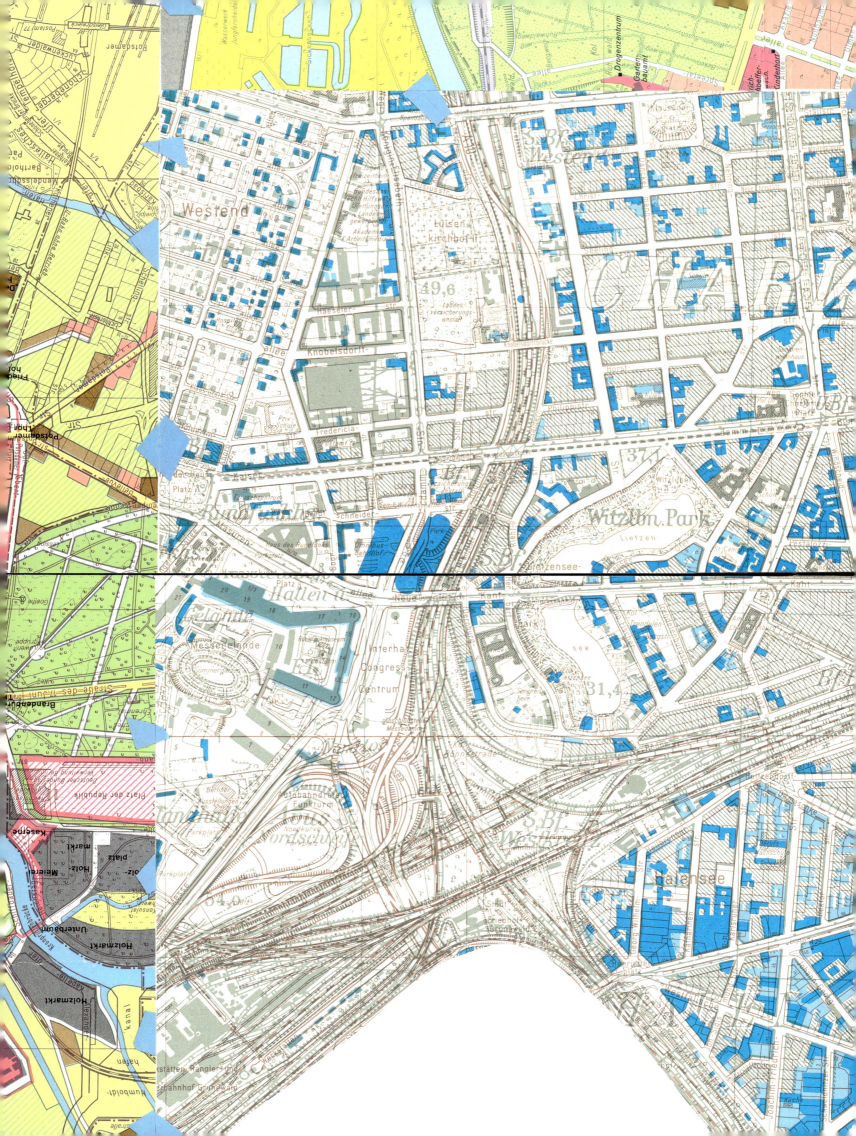

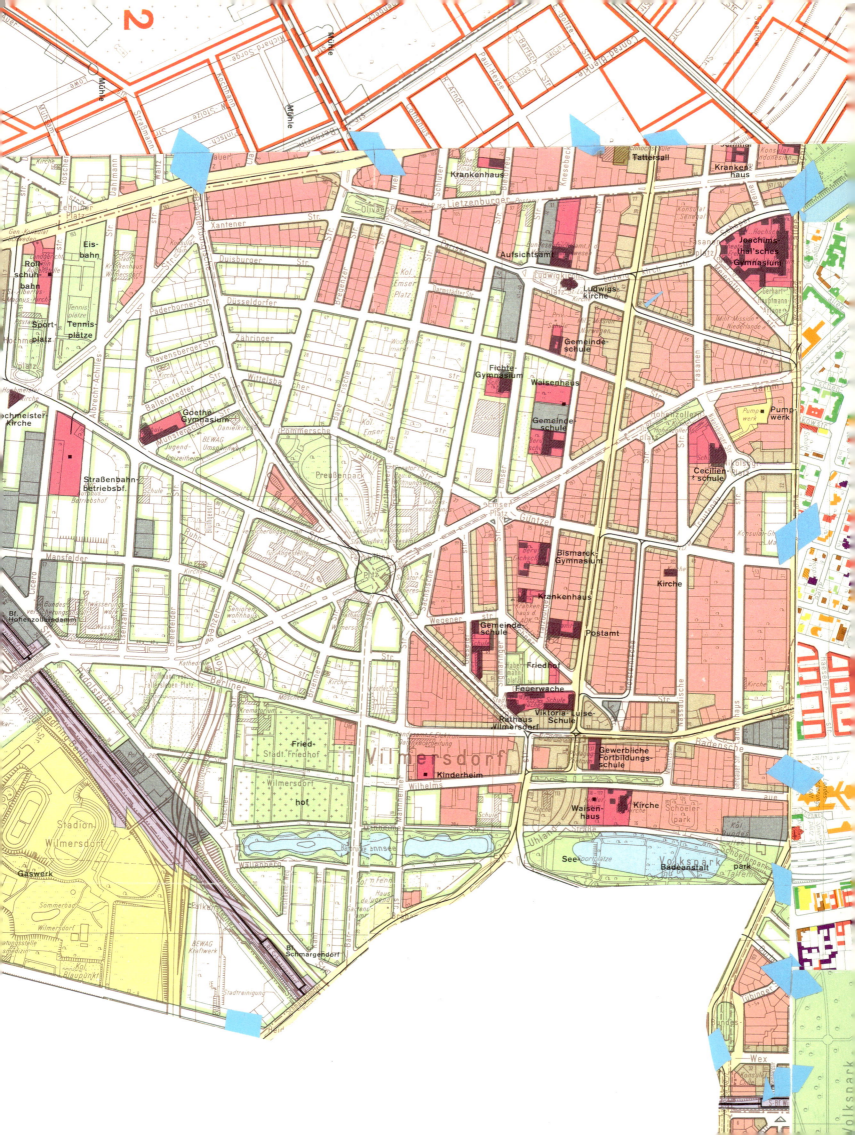

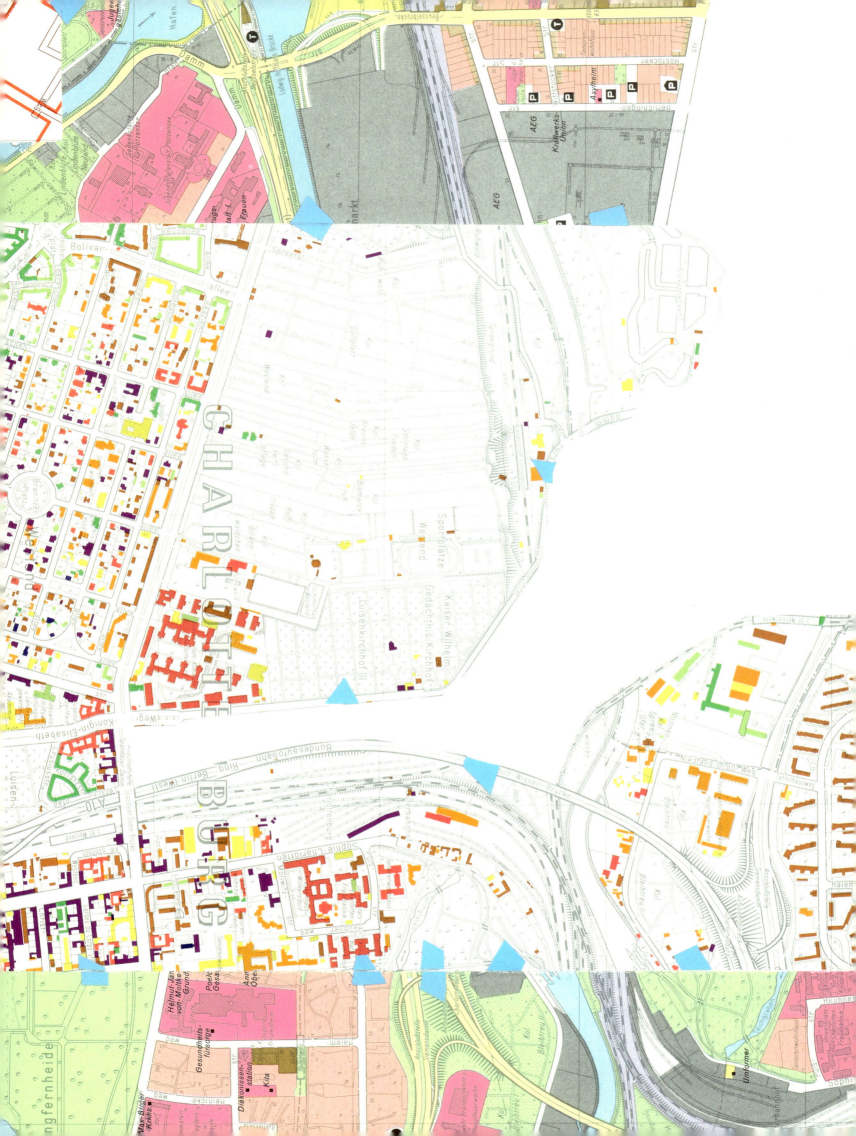

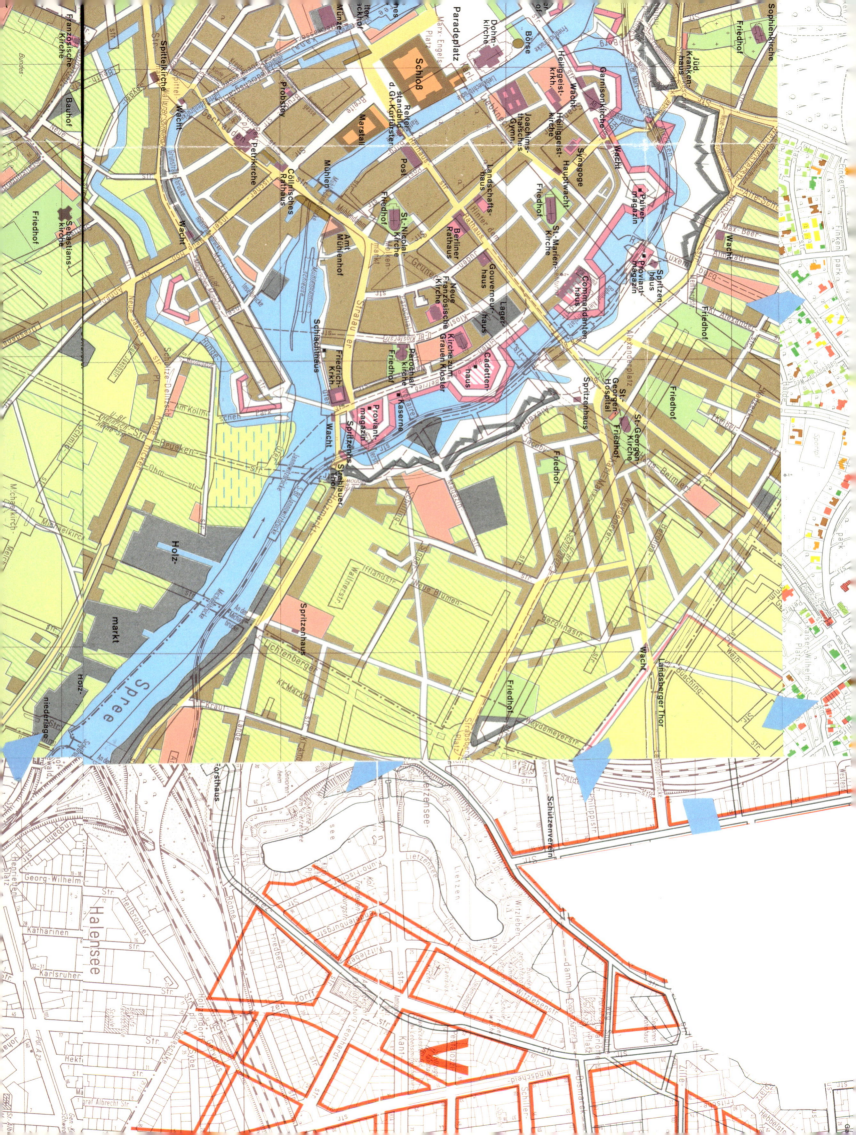

Je est un autre

The title, borrowed from French poet Arthur Rimbaud, translates roughly to "I is another," which speaks to my rejection of purist or reductionist worldviews. In this most recent series, image fragments are selected, hand-cut directly from books, and reassembled to create new spaces and narratives. This body of work samples imagery from photographs taken by significant figures during the golden age of postwar architectural photography, when Julius Shulman, Lucien Hervé, and Ezra Stoller used high-contrast black-and-white photography to emphasize forms.

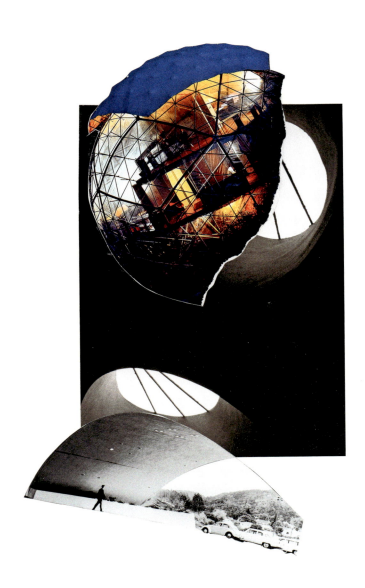

We Need Holes, 2019
Collage on archival paper, 13 × 10 in.

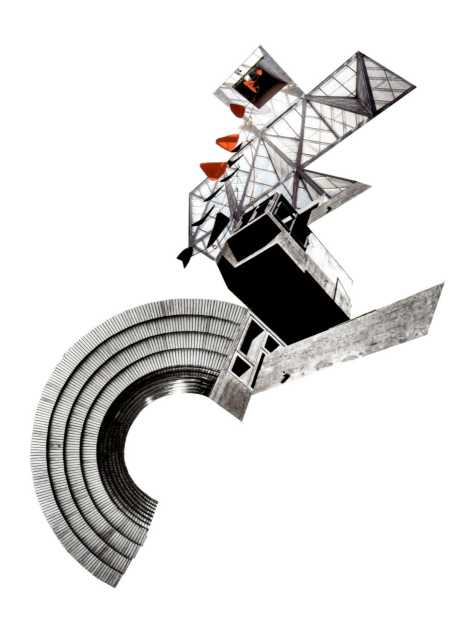

Error as Hidden Intention, 2019
Collage on archival paper, 13 × 10 in.
Private collection, New York, NY

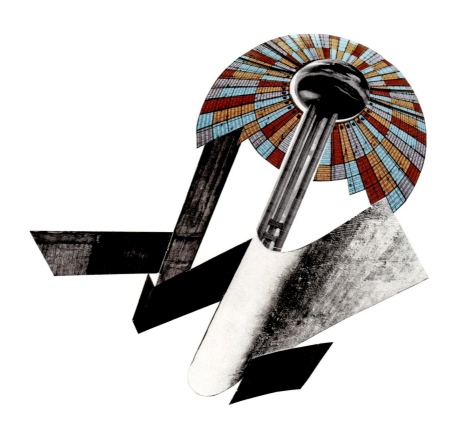

The Thing Most Easily Forgotten, 2019
Collage on archival paper, 10 × 13 in.
Private collection

The Principle of Inconsistency, 2019
Collage on archival paper, 17¾ × 23⅜ in.
Collection of Sharon Bautista

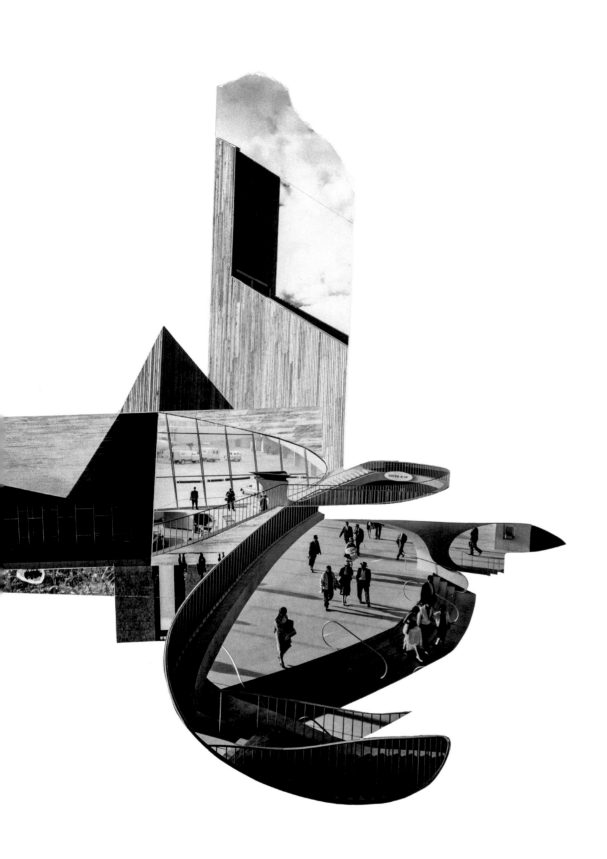

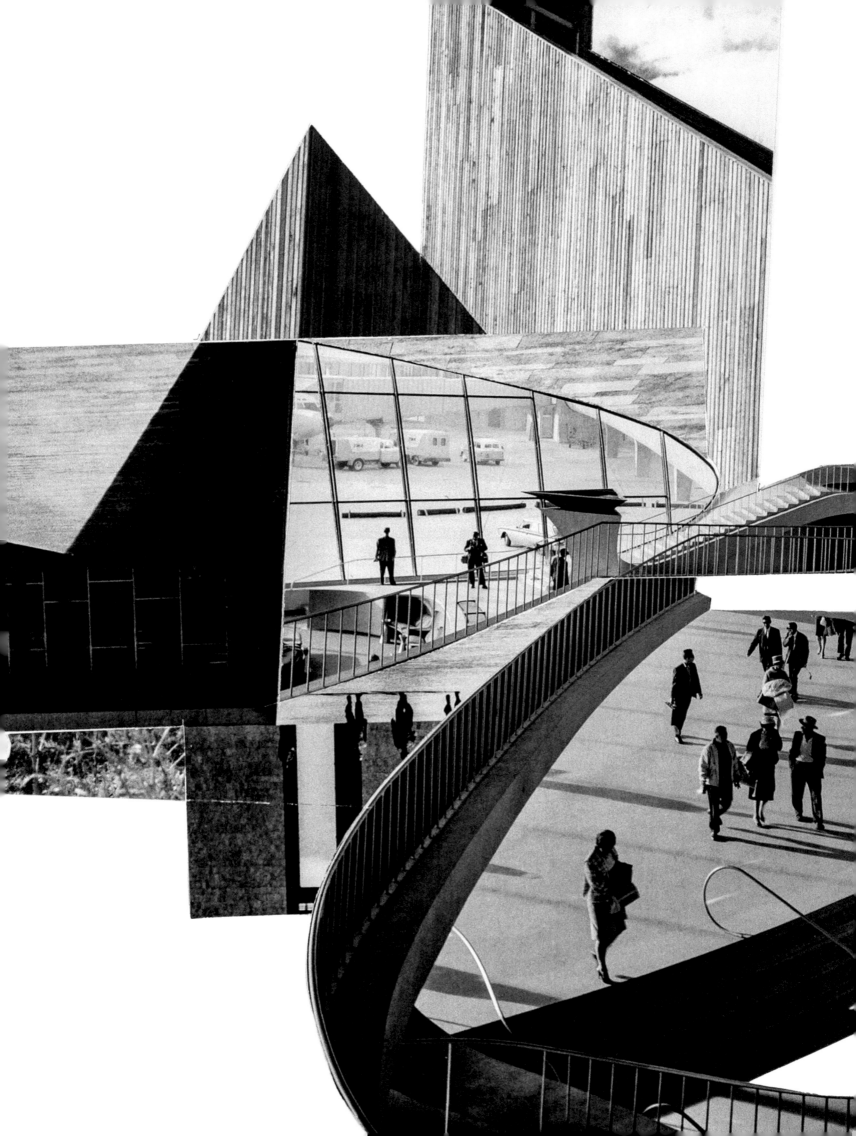

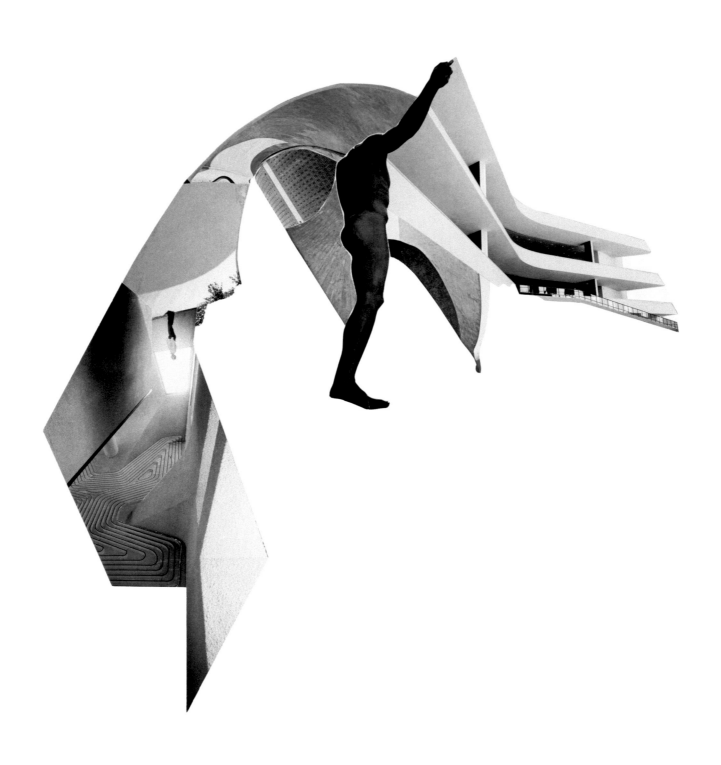

Repetition as a Form of Change, 2019
Collage on archival paper, 23½ × 18 in.

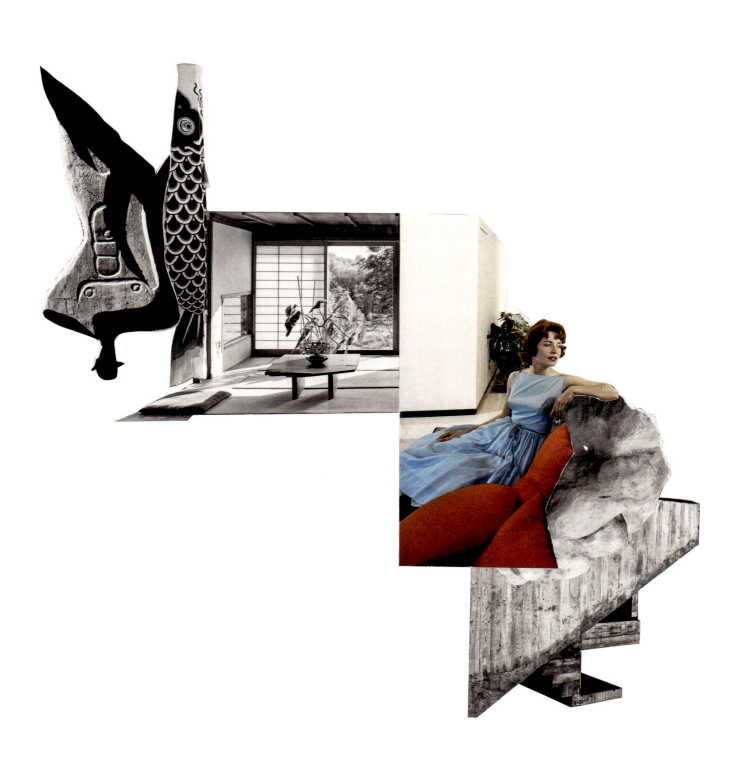

A Choice to Do Both, 2019
Collage on archival paper, 23½ × 18 in.

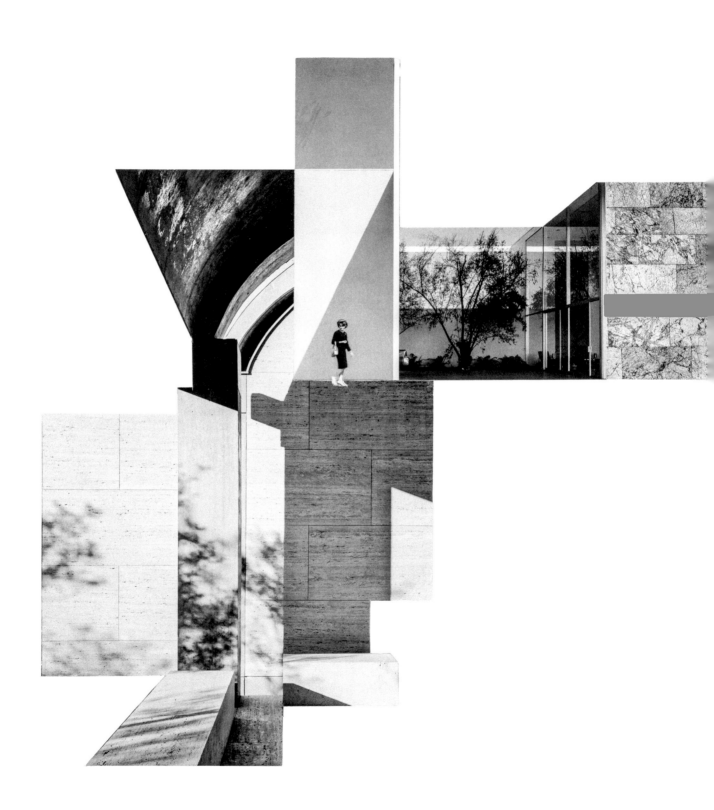

A Part, Not the Whole, 2019
Collage on archival paper, 18 × 23½ in.
The Art Institute of Chicago
Purchased with funds provided by the Chauncey and Marion D. McCormick Foundation, 2020.16

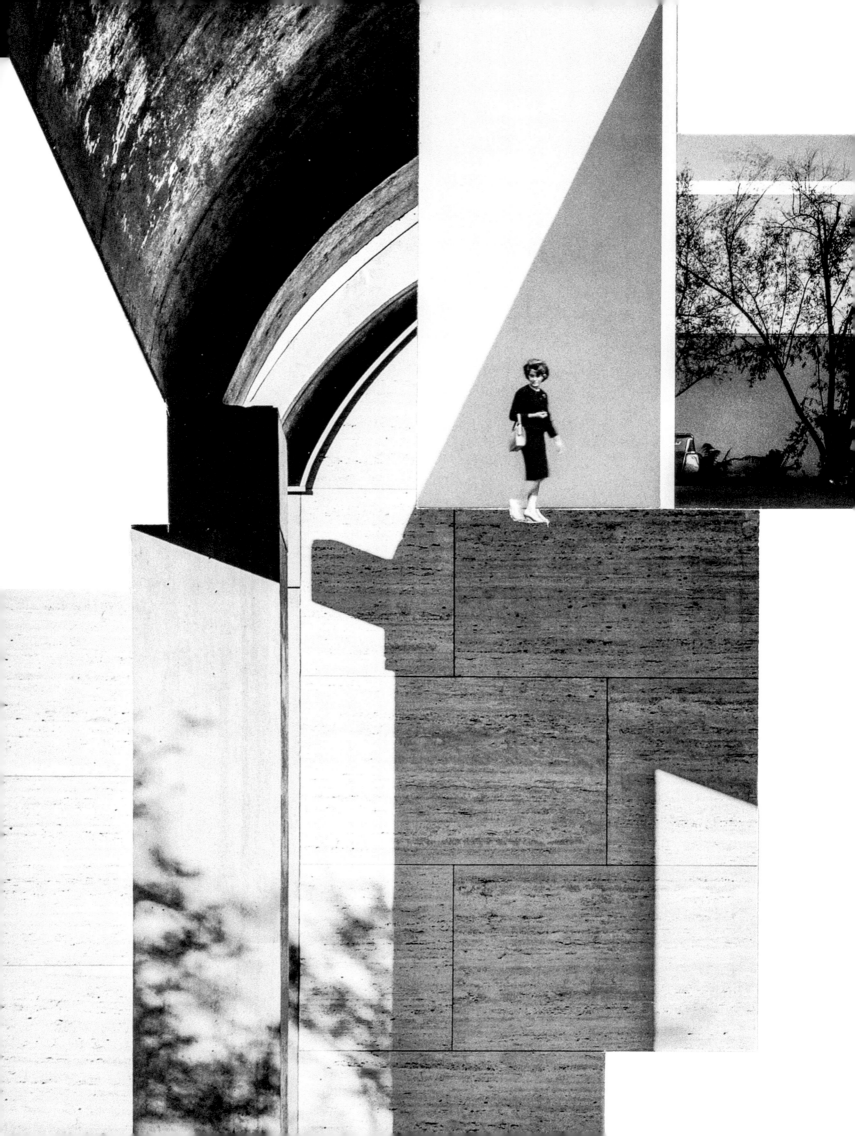

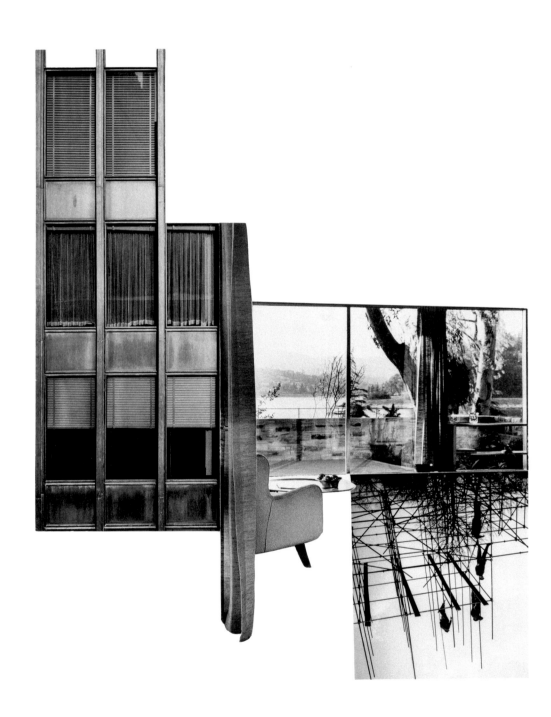

Nothing for as Long as Possible, 2019
Collage on archival paper, 23½ × 18 in.
Santa Barbara Museum of Art
Museum purchase with funds provided by the General Art Acquisition Fund, 2022.8.3

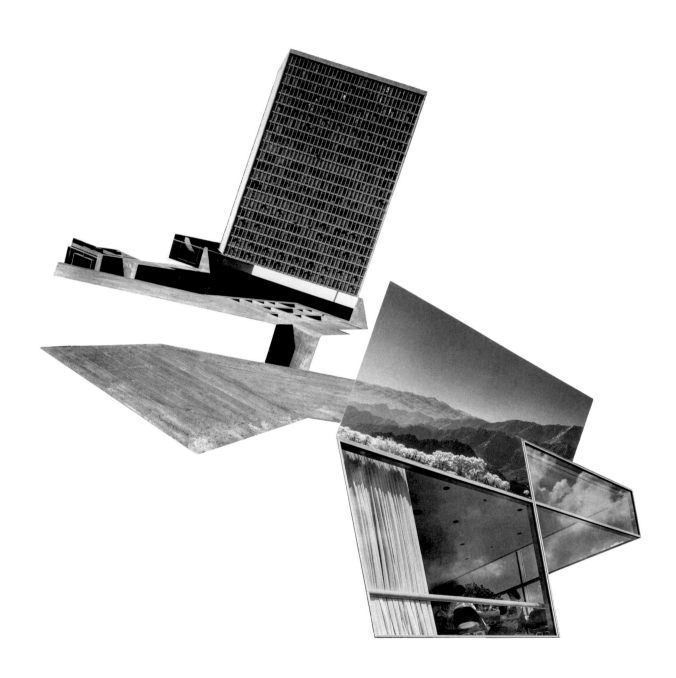

Easement, 2019
Collage on archival paper, 23½ × 18 in.
Santa Barbara Museum of Art
Museum purchase with funds provided by the General Art Acquisition Fund, 2022.8.2

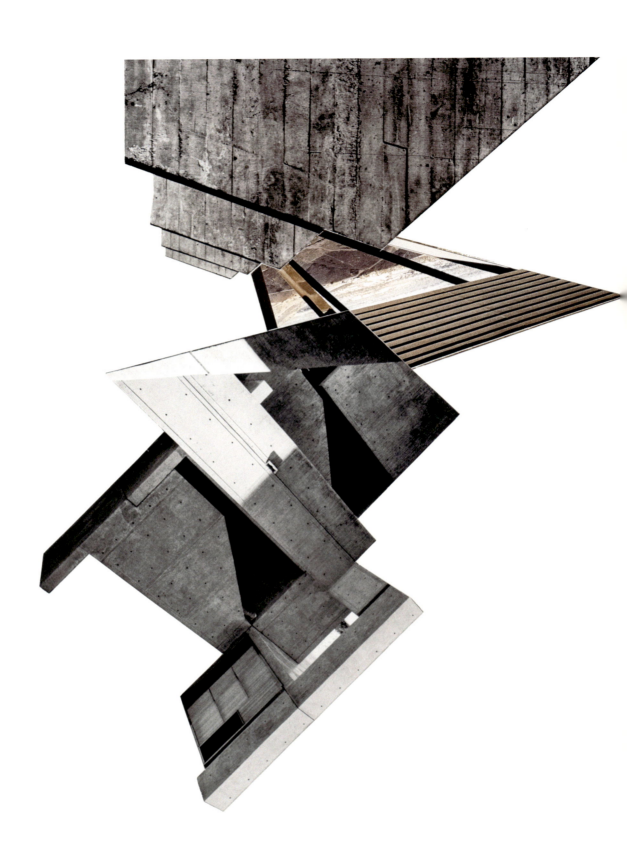

Accretion, 2019
Collage on archival paper, 18 × 23½ in.
The Art Institute of Chicago
Purchased with funds provided by the Chauncey and Marion D. McCormick Foundation, 2020.15

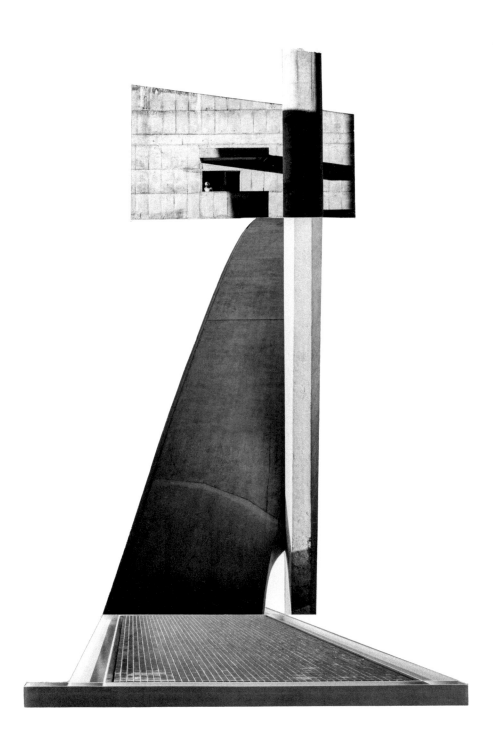

Toward the Insignificant, 2019
Collage on archival paper, 23½ × 18 in.
The Art Institute of Chicago
Purchased with funds provided by the Chauncey and Marion D. McCormick Foundation, 2020.17

Notes from the Joint: Collage Ethics
Anna Arabindan-Kesson

A certain kind of promiscuity underlies the project of collage. Its inventiveness—in the history of art—emerges from a process akin to mingling, rather indiscriminately and with various degrees of intimacy, an assortment of materials. It is this (un)process and resulting heterogeneity of form that undercuts the principles of artistic autonomy or the mimetic function that art appears to hold.[1] Because collage requires minimal dexterity and uses materials from magazines, newspapers, disused books, and even trash, it should contribute to undermining ideas about artistic integrity and the singularity of artistic invention. However, collage and its history have been used to reinforce ideas about artistic genius and, in turn, a restrictive canon of Western modernism. Of course, the radicality of collage as a narration of avant-garde's history is only one of its many lives, as recent exhibitions and conferences that decouple the form's immediate association with Western modernism remind us.[2] Marshall Brown also enacts a decoupling of collage from its familiar history, though in an apparently deceptive way: the smooth angularity and chromatic surfaces of his collages seem to reflect an interest in these canonical modernisms. Move a little closer, however, and you'll see it is the libidinous visuality of collage, with its energetic mixing of misaligned matter and form, that inspires his collages' inchoate chimeric worlds of myth and fantasy. This artist-architect asks us to see collage as a process of intermingling, through its registers of intimacy and its creative fusion. The ethics of Brown's collages, as mentioned in the essay's title, emerge from their ability to reflect and expand the canon of architecture.

Another aesthetic of collage draws on the potential of these chimerical processes and is often framed through its potential to disrupt. In the 1960s and 70s particularly, feminist artists used collage as a form of protest, a means of engaging art and activism. It is tempting, I think, to approach Marshall's collages in that vein too. But the more I look at his angular dreamscapes, his forms seem less about the act of disruption and more about creating a space of interruption. The difference is important. Disruption upends, causes disarray, but interruption inserts something in its place. Marshall's collages visualize—create a framework for understanding—how fields like architecture (and art history) have rested on the production of genealogies—of form, of influence, of change—while also emphasizing a search for originality. In an earlier text, Brown describes his collages as a form of creative miscegenation. In the United States, this term immediately recalls the racist legislation that structured this nation's political and legal system and prohibited mixed marriages. Using the term *miscegenation* to describe the "architectural half-breeds" he creates might seem provocative because it calls attention to the fact that art and architecture are invested in a certain kind of purity—of form, of authorship, of intent—that also belies the entanglement of influences, of aesthetics and everyday life, of form and function, that have always sustained their production and legibility. His hybrid forms address, reflect on, and model the referentiality, the mixing of sources, that make architectural forms (and artworks) legible in the first place. In embedding this history within his forms, he also draws attention to how these myths of purity that appear in art history—and architecture—under the guise of a relentless search for originality, through the tracing of influence inevitably become modes of gatekeeping. An art historical approach often traces sources to understand where a form came from, with whom an artist might have studied, or by whom they were inspired. While this looking backward can appear neutral, it can also reinforce the canon of European artists and prototypes against which others are judged for either being not good enough, or too imitative and therefore unoriginal. Considering, too, how a discipline like art history has long been associated with the formation of whiteness and the promotion of white supremacist ideologies—including through the aestheticization of racial hierarchies, as in the writing of Johann Joachim Winckelmann, for example—Brown's use of the term *miscegenation* is even more urgent. His collages force consideration of how art historians analyze and interpret art and the wider implications of our methodological investments beyond the limits of a discipline.

While Marshall is skeptical about architecture's role in shaping our social conditions, he is fully cognizant of how architecture is shaped by the social. His collages are not created to advance the social benefits of architecture, but their promiscuity as hybrid forms returns us to the process of their formation as a means of navigating our experiences now. As he

[1] For a very brief overview of collage and its associations with modernism, see Brandon Taylor, *Collage: The Making of Modern Art* (London: Thames & Hudson, 2006); Hal Foster et al., *Art since 1900: Modernism, Antimodernism, Postmodernism*, 2nd ed. (London: Thames & Hudson, 2011); Budd Hopkins, "Modernism and the Collage Aesthetic," *New England Review* 18, no. 2 (1997): 5–12, http://www.jstor.org/stable/40243172; Monica Kjellman-Chapin, "Traces, Layers and Palimpsests: The Dialogics of Collage and Pastiche," *Konsthistorisk Tidskrift/Journal of Art History* 75, no. 2 (June 1, 2006): 86–99, https://doi.org/10.1080/00233600500399403.

[2] See, for example, Paul Mellon Centre, "Collage Dreamings and Collage Hauntings: Cutting Edge," accessed December 21, 2021, https://www.paul-mellon-centre.ac.uk/whats-on/forthcoming/collage-dreamings-collage-hauntings; and Patrick Elliott, Freya Gowrley, and Yuval Etgar, *Cut and Paste: 400 Years of Collage* (Edinburgh: National Galleries of Scotland, 2019).

describes when I meet him in his sun-filled studio, there is an appropriative register to collage to which he is deeply attracted. We might call this a mash-up, or a remix. He calls it an ethics of collage in which appropriation drives the process of recombination and reveals his research-based historical engagement with the history of modern architecture.

As we talk, Marshall directs me to the pile of architectural photography books he has stacked against his wall, their pages layered with colored sticky notes. He flicks through them, and I recognize scenes that have already been spliced into the chrome, glass, and sometimes landscaped phantasmas gliding against his studio wall or stacked in boxes under his desk. In keeping with his collage ethics, Marshall chooses photographs that appeal to him and then photocopies them. He then sets to work, laying them flat on his workspace, dissecting them into the segments he requires. While the actual process is not necessarily fast—cutting can take time—it is premised on a rapidity directly opposed to the *longue durée* of architecture. He is deeply invested in the speed of the photocopy, which dashes out of the machine ready to be cut up and glued, versus the slowness of a scan on a flatbed scanner, which requires considerably more time to capture and then manipulate. Rather than planning out the cut with pencil first, he harnesses the deft immediacy of the scalpel as the means of organizing shape. He incorporates these preparatory cuts into the final product by allowing the misalignments of the dissection and the rough edges of the paper to remain. While the collages are the creative output, they also materialize process and reveal their own experimental organization. This ethics of collage incorporates method and form into a systematic framework that reflects on and reconceptualizes our contemporary relationships to space and social connection.

Over time, the forms Marshall creates have grown progressively larger as he has experimented with scale and support. The glossy, geometric forms of *Chimera* are noticeably smaller and flatter, even when they hang on the wall, revealing their reliance on the paper to support their configuration in the viewer's space. In *Prisons of Invention* the collages are larger, more vertiginous. They seem to move out from and activate the heavy watercolor paper that supports them, to create a more immersive experience for us. In *Chimera*—referring to the creatures of Greco-Roman mythology, Marshall manipulates mostly architectural photography into new fusions of imaginary urban space. Across these scenes we are captivated by the reflection of surfaces from which we can investigate worlds somewhere beyond, yet around, the world we inhabit now. Although made from the ordered and clean-lined images of architectural photography, these collages want to mutate, to spread, and to consume what is around them. (My reference to the *Alien* series here—films that, if nothing else, are about the possibilities of intermixing—is intentional.

Still from Jean-Pierre Jeunet, *Alien: Resurrection*, 1997
© Twentieth Century Fox. All rights reserved

Marshall references the films in our conversation, pointing out that by the series' end, the boundary between human/alien is almost indecipherable.) This increasing scale tracks his collage experiments. We move from the flattened dynamism of *Chimera* to the larger-sized *Prisons of Invention*, whose vibrant color and angular reflective surfaces hover, spinning outwards across their white ground. They expand into explosive forms that reach out toward the viewer, evoking, as Marshall describes to me, theories of material velocity and gravitational force advanced by early-twentieth-century Russian filmmakers, most prominently Sergei Eisenstein.

Sergei Eisenstein at work, 1927
RGALI, 1923/1/217, f.1
© Russian State Archive of Literature and Art

To move from *Alien* to Soviet avant-garde film may seem abrupt. Nonetheless, just as the works themselves are taken from a range of architectural photographs, they are also informed by a wide-ranging (promiscuous) incorporation of theoretical frameworks and artistic sources.

Along with these filmic references, Marshall also directs me to precedents for his role as an artist-architect. There is Michelangelo, of course, but also Giovanni Battista Piranesi (1720–1778), who was trained as an architect and made books and sketches of Roman architecture.

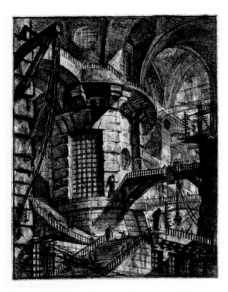

Giovanni Battista Piranesi, *The Round Tower*, n.d. Etching on paper, later state, 21⅜ × 16¼ in. Santa Barbara Museum of Art, gift of Ala Story in Honor of Wright Ludington, 1965.29

Marshall's title, *Prisons of Invention*, is a direct appropriation of the artist's eighteenth-century series *Carceri d'invenzione* [Imaginary Prisons] (ca. 1749–50), which depicts the fantastic architecture and passageways of subterranean vaults. The suite of sixteen prints, with their tonal contrasts, detailed rendering, and disorientating scale are ominous and highly inventive. Marshall has long been fascinated by this series and the questions it asks about orientation and definition. In Piranesi's prints, it is impossible to know where you are standing, for you cannot see the ground or the sky. It is also hard to decipher what you're seeing: are these ruins or structures being built? Perspectives collide and topple, changes in scale take place without any warning. There is a similar effect in Marshall's *Prisons of Invention*, where each collage takes its name from one of Piranesi's prints. These works amplify the verticality of the "hang." In each collage, the mixture of textured surfaces creates an interlocked movement across the white background that expands in multiple directions, like half-formed robotic arms or swaying towers. They force themselves out of the paper, emerging like hybrid creatures of many parts, ready to enfold, encase, and consume. Marshall's process hinges on an integration of sources and influences that span a wide-ranging geography and chronology. This synchronicity is another crucial aspect of his collage ethics.

His collages are lessons in the history of modernist and contemporary architecture while also being part of that history and genealogy. This is materialized in his newest collage, a multilayered reimagining of Berlin made from maps of the city [p. 57]. They are gorgeously colored, alluring, seductive, and immersive. Evoking the imaginary cities that Italo Calvino described, Marshall's map of Berlin will take you nowhere fast.[3]

As you walk through streets, across parks, around plazas, and up stairs, you might move centuries away or return to where you began, immersed in a dreamscape shifting simultaneously between dislocated worlds and unrelated temporalities. The world is labyrinthine yet expansive. The result or the effect of this morphology of form and process is that our engagement with Marshall's mutating collages has become, progressively, a far more immersive experience. We are compelled to participate in a generative process, to imagine traversing the city represented by the map and becoming part of the mix.

To look at Marshall's collages is to see surfaces of glass, concrete, steel, wood, sometimes landscapes and sometimes bodies that have coagulated into geometric forms. They are sleek and angular. At times they look like jagged cityscapes, with vertiginous lines and pointed edges. Sometimes they look like pistons, intergalactic rockets, or the mechanical components of a racing car. This effect relies on architectural photography as it mediates the interpretation of three-dimensional space, with the inevitable flattening that occurs in photography's pull toward indexicality. Architectural photography must preserve the spatial dynamics of architecture while allowing viewers to recognize and interact with that space, as a three-dimensional structure, from new perspectives and in new positions. Architectural photography creates the illusion of an embodied response. Architectural photography succeeds when viewers feel as if they know the building and can identify that they are there and seeing it in real life. Yet in both *Chimera* and *Prisons of Invention*, recognition is tempered by disorientation and an uncanny feeling.

Defamiliarizing our own relationship to space, and our own processes of recognition, Marshall's interbred forms shift the nature of collage itself, moving away from its aesthetics of disruption, perhaps even away from collage's manipulation of the fragment, to framing the practice as something like an aesthetics of the joint. The joint is a pathway through the edge, a beginning from an ending, a form shaped by the cut. A joint signifies anatomical violence—segments of a body carved—while also describing the structures holding that body together. The joint evokes the sharpness of the dissection and construction that underpins collage. It materializes the oppositional forces encapsulated in this process—the creative formation that emerges from the destructive act of cutting. When you look closely at Marshall's collages, particularly in *Prisons of Invention*, you'll notice small pieces of tape holding edges in place. The tape is a place marker as much as a joint. It is improvisatory and quick. It holds segments together, marking both the limits and the beginnings of

3 Italo Calvino, *Invisible Cities*, trans. William Weaver (New York: Houghton Mifflin Harcourt, 2013).

4 Patricia Hills, "Cultural Legacies and the Transformation of the Cubist Collage Aesthetic by Romare Bearden, Jacob Lawrence, and Other African-American Artists," *Studies in the History of Art* 71 (2011): 221–47, http://www.jstor.org/stable/42622542; Lorna Simpson, *Lorna Simpson Collages* (San Francisco: Chronicle Books, 2018); Ruth Fine and Jacqueline Francis, eds., *Romare Bearden, American Modernist* (Washington, DC: National Gallery of Art, Center for Advanced Study in the Visual Arts, 2011).

5 Kobena Mercer, "Romare Bearden, 1964: Collage as Kunstwollen," in *Cosmopolitan Modernisms*, ed. Kobena Mercer (Cambridge, MA: MIT Press, 2005), 124–45.

6 Huey Copeland, "Tending-toward-Blackness," *October*, no. 156 (May 1, 2016): 141–44, https://doi.org/10.1162/OCTO_a_00249.

the form. The works have their own internal consistency that paradoxically comes from all these references and parts. For instance, a brick wall against a glass window or concrete floor appears like the internal components of a single structure. It is this internal integration that the blue tape signals. These sticky pieces are like thick, flat sinews or vessels that connect and congeal. They mark out the joints that hold these pieces together, while also materializing the porous boundaries of collage. If the joint indicates the internal consistency of the collage form, then it also demonstrates the breakdown of form that collage must sustain. Collage hinges on this disjuncture, on the constitutive elements of intermingling and the dissembling that this must generate.

It is this disjuncture that also animates our continued engagement with these works. While the small strips of tape activate this relationship, they also activate the surface in other ways. Look closely and you will notice tears here, or a graze there, where these pieces of tape have pulled away from the paper, leaving a roughened outer layer. These momentary disruptions of the surface signal to me the shifting layers that collage must synthesize into something new. These tears are metonymic gestures of the collage's resistance to dissolution or illegible chaos, and the internal cohesion that it must maintain through a fragmented, fragile unity. But the tear, the cut, the joint, also calls up another genealogy of collage as it has functioned in the Black diaspora: from the "crazy quilt" walls in the cabins of rural Black communities to the stitched surfaces of Romare Bearden's collages made from photocopied photographs to Lorna Simpson's layered portraits assembled from magazines like *Jet* and *Ebony*. For them, the tear and the cut have been the means of improvisation, activation, and reformation.[4]

As Kobena Mercer has written in relation to Bearden's work, the collage aesthetic has been used to probe both individual subject and community formation, its improvisatory gestures animating a range of Black social, cultural, and political practices, while allowing for the heterogeneity of Black experiences.[5] The promiscuity of collage opened generative possibilities that Black artists harnessed for cultural expression and cultural critique. These often relied on, and leaned toward, the creative practices of Black communities as they continuously constructed unimagined forms of relationality and collectivity.

Although slight, these tears and skinned pages, as remnants of the joint, visualize both the limits and the possibilities of Marshall's material forms. They are fragile anchors that place us amid the works' unfolding, bringing us closer to the constitutive elements of the work at the very moment of its dematerialization. Marshall's work is not a direct commentary on either his experience as an African American man in the United States or on the racial dynamics that structure this nation. However, his collage ethics—his investment in the improvisatory nature of collage and its relationality—seems to offer the space for what Huey Copeland has called an "ethical posture ... a tending toward ... black subjects and those forms of [life] positioned at the margins of thought and perception yet ... necessarily co-constitutive of them."[6] Through our interaction with these collages, we become more cognizant of the processes that entangle the social spheres we move through and their margins of (dis)connection. And so, by pulling us into this process and making us see how the collages are held together, how they physically cohere with tape, glue, and roughed edges, Marshall also pulls us toward the possibilities of alternative social formations, of world-building that might emerge, should we take notice of them.

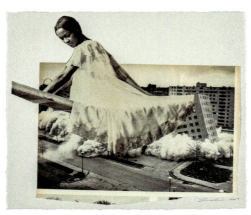

Lorna Simpson, *Night Gown*, 2019
Collage on paper, 9⅞ × 11¾ in.
Framed: 11⅜ × 13¼ × 1½ in.
© Lorna Simpson. Courtesy the artist and Hauser & Wirth
Photo: James Wang

Prisons of Invention

The worlds portrayed here invoke an expanding range of scales, from architectural to urban to landscape, while challenging our experience of gravity, orientation, and space–time. Borrowing their name from Giovanni Battista Piranesi's etching series *Carceri d'invenzione* (ca. 1749–50), these collages mark a significant increase in scale and complexity, creating immersive visions reminiscent of the Italian master's multilayered imaginary prisons.[1] The enlargement process requires seams to be used both within and between image fragments. Artist's tape for temporary positioning is not removed but remains as part of the work, and the source material comes entirely from a select group of photographers working on architecture, urbanism, and landscape at the beginning of the twenty-first century.

1 Giovanni Battista Piranesi (Italian, 1720–1778) apprenticed as an architect and became famous for his etchings and books depicting views of Rome, as well as his famous map of Rome created together with Giambattista Nolli (1748). The first fourteen *Carceri d'invenzione* etchings were created between 1749 and 1750 before being reissued in 1761 as a series of sixteen.

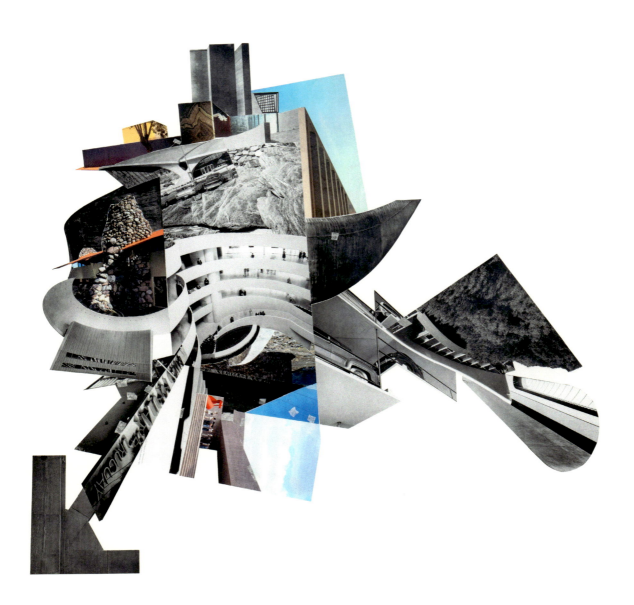

Pantheon, 2020
Collage on archival paper, 43 × 45 in.
Santa Barbara Museum of Art
Museum purchase with funds provided by the General Art Acquisition Fund, 2022.8.1

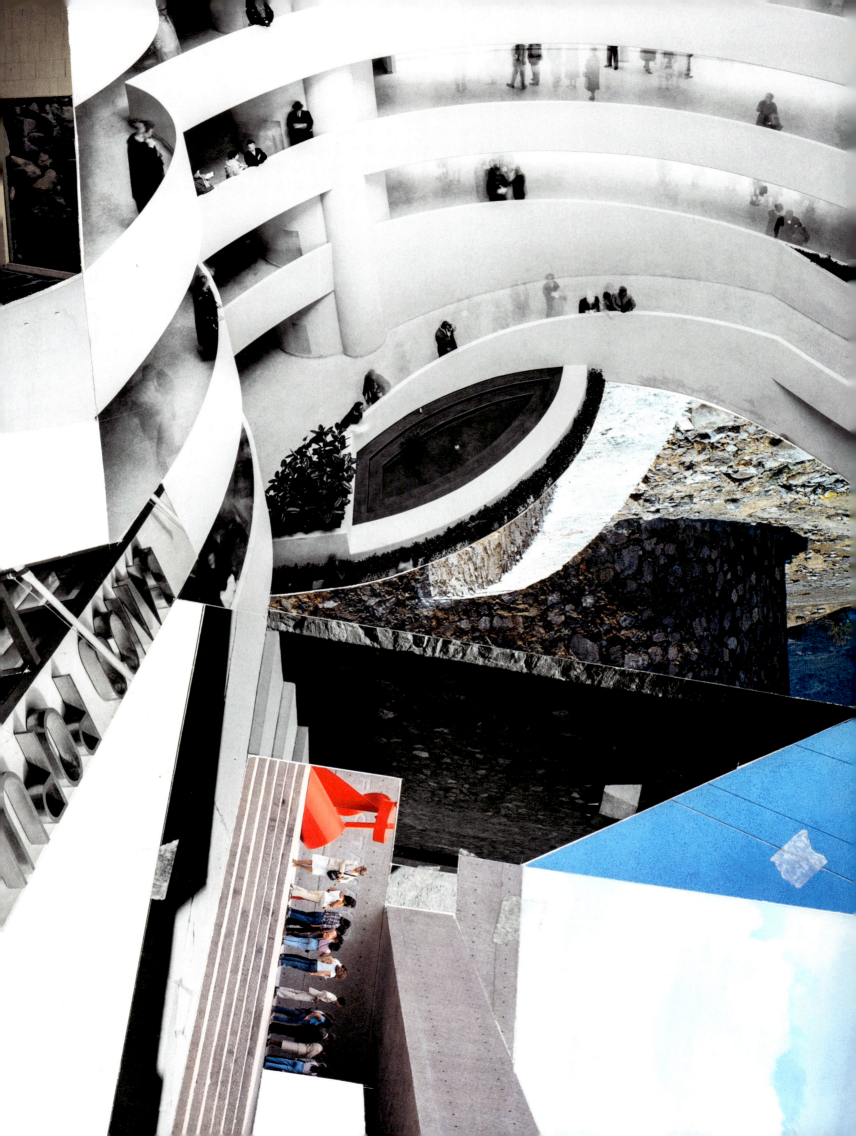

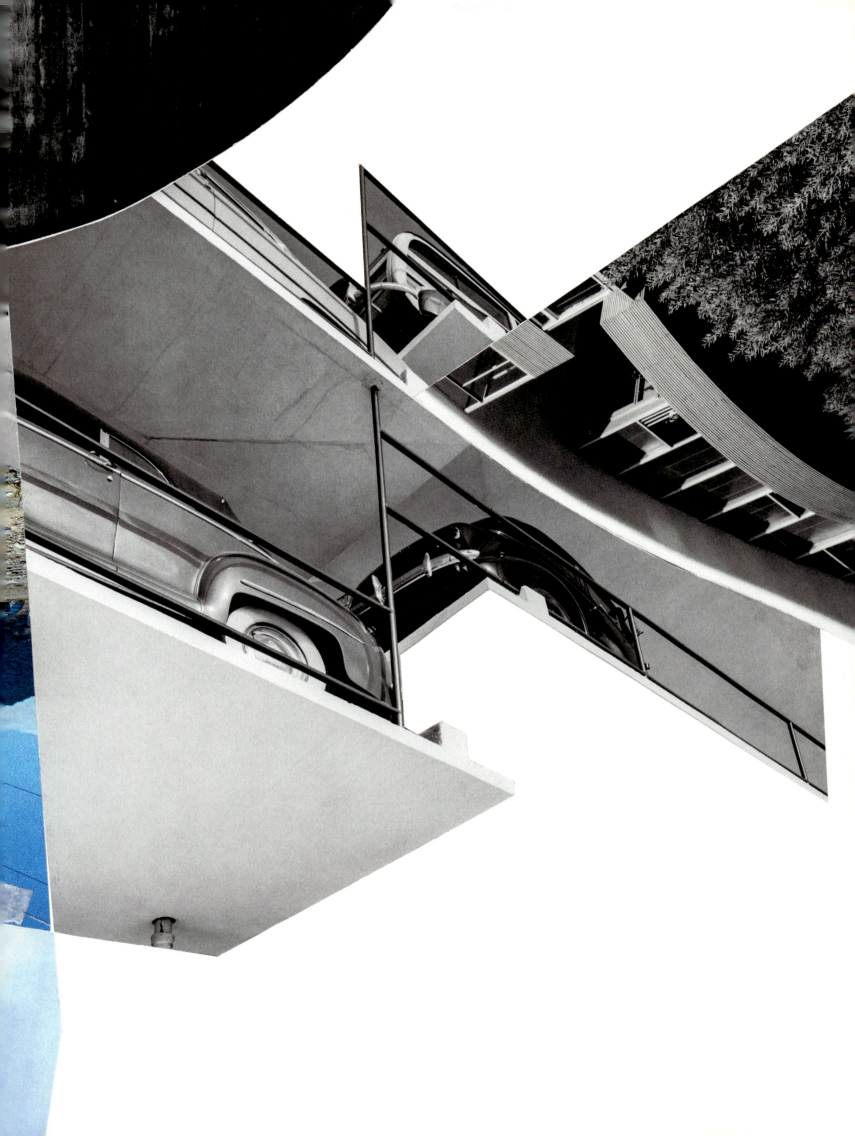

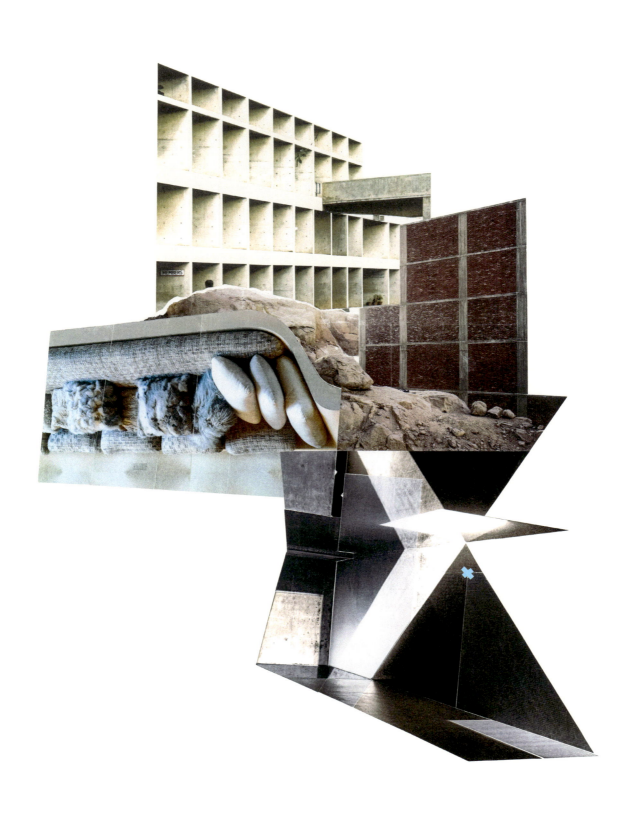

The Well, 2021
Collage on archival paper, 45 × 36 in.

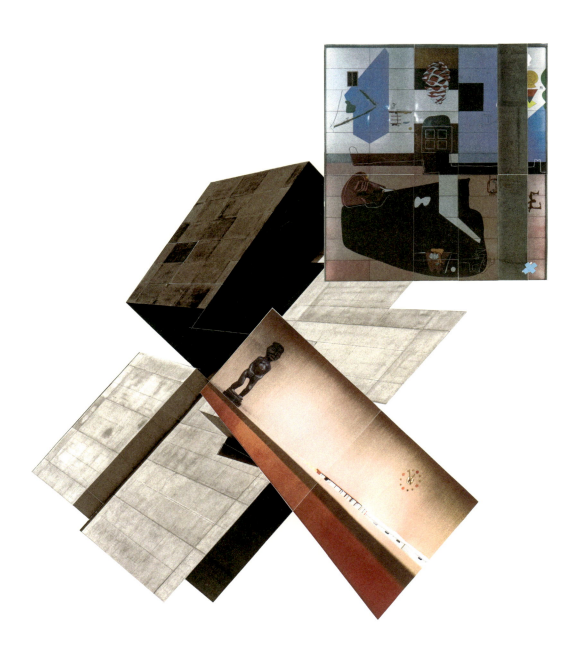

The Staircase with Trophies, 2021
Collage on archival paper, 45 × 32½ in.

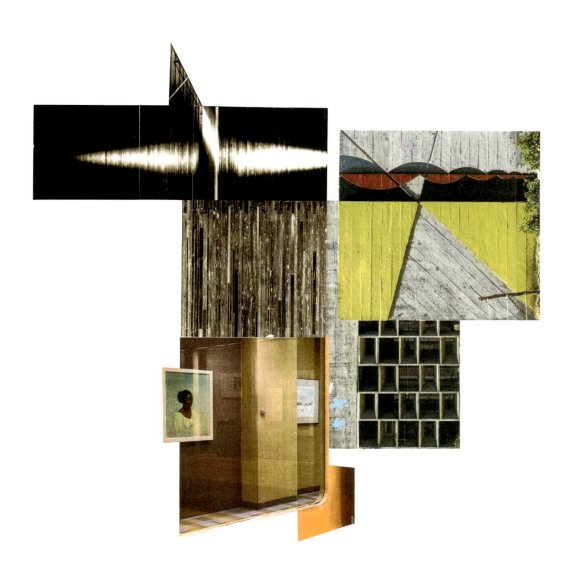

The Smoking Fire, 2021
Collage on archival paper, 36 × 36 in.

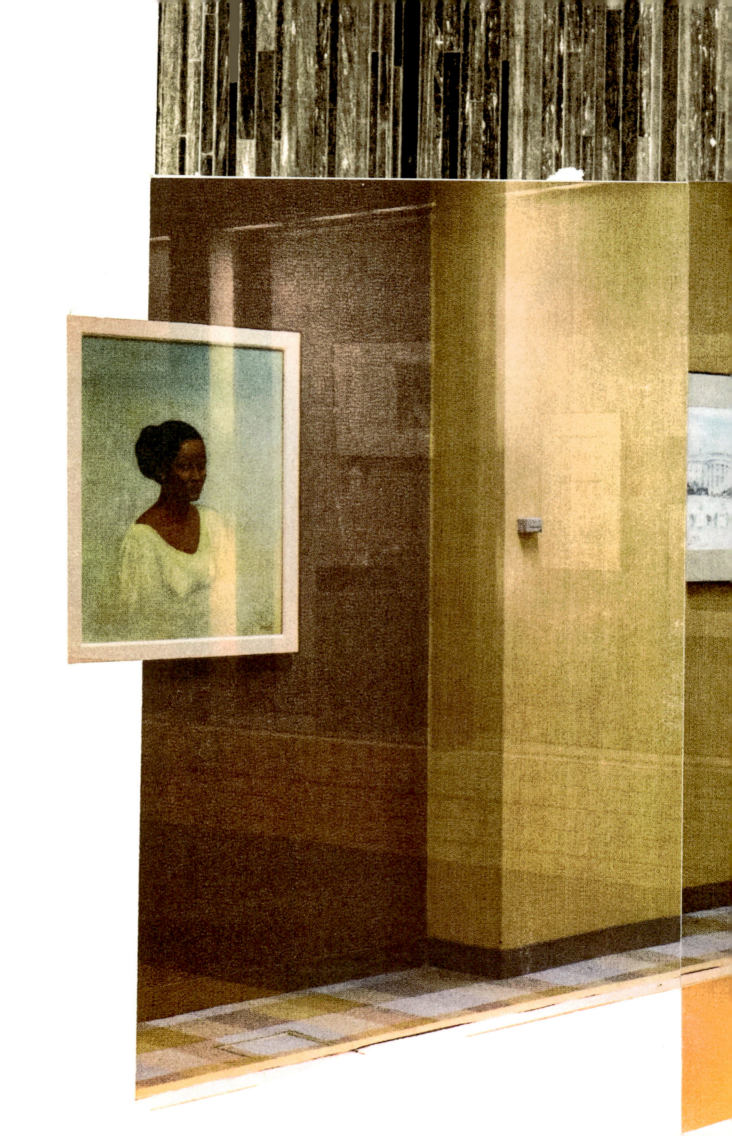

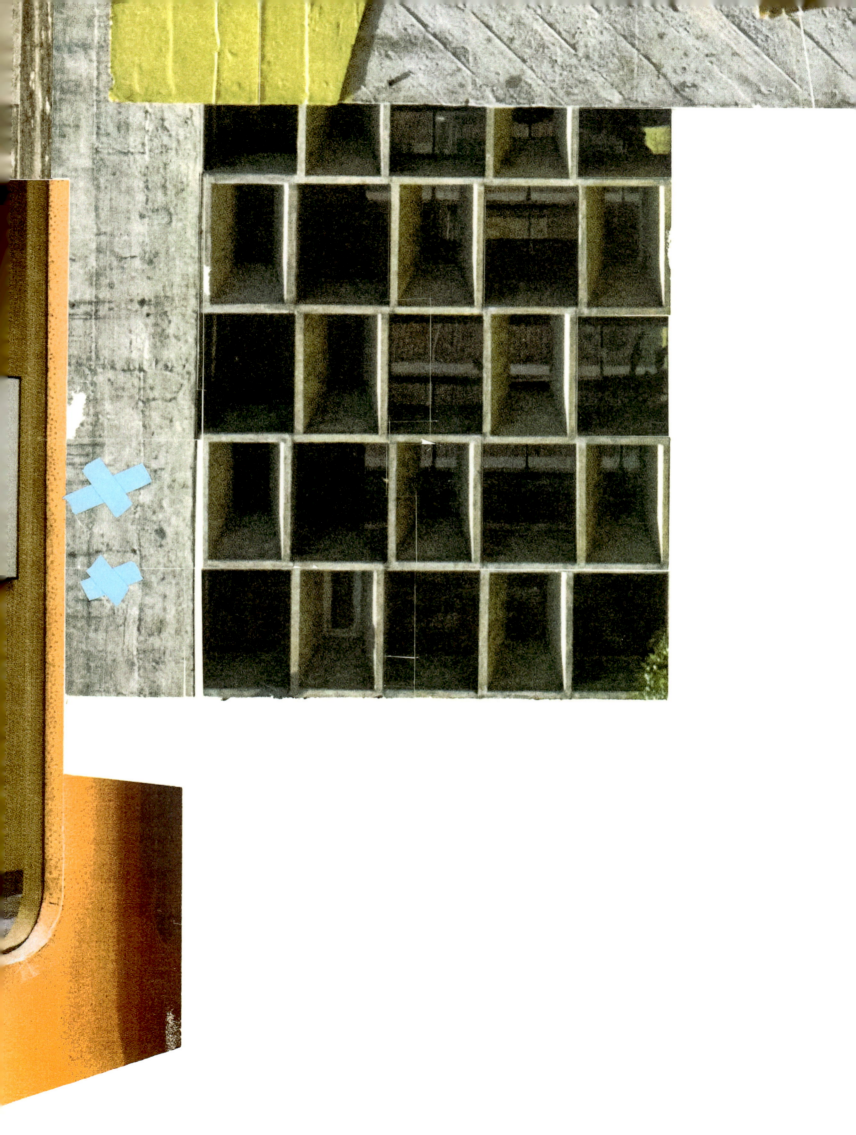

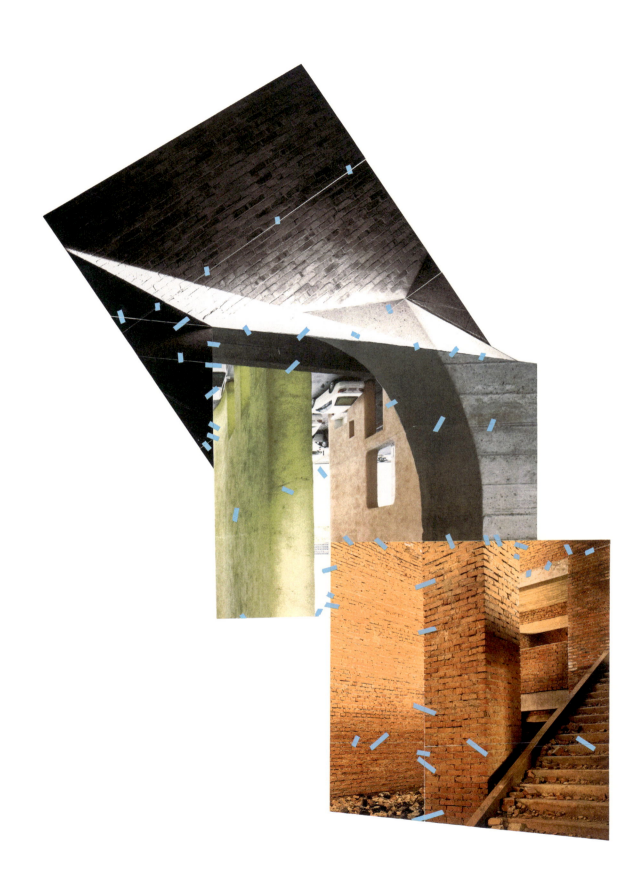

The Gothic Arch, 2021
Collage on archival paper, 45 × 33 in.

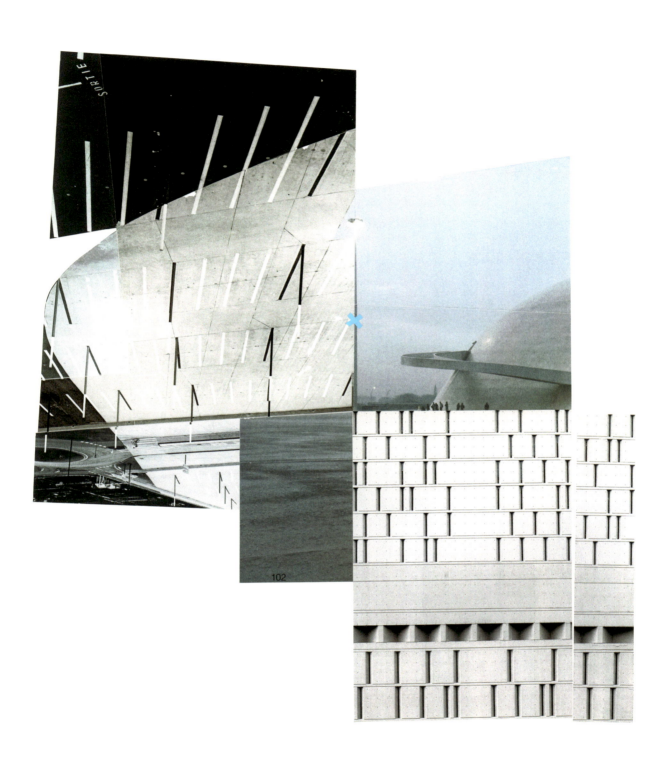

The Grand Piazza, 2021
Collage on archival paper, 44¾ × 36 in.

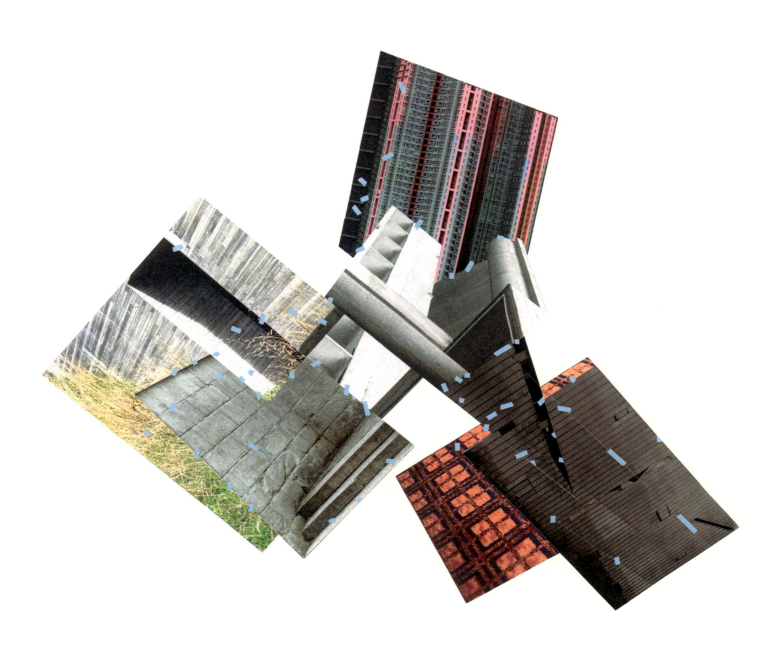

The Drawbridge, 2021
Collage on archival paper, 36½ × 36½ in.

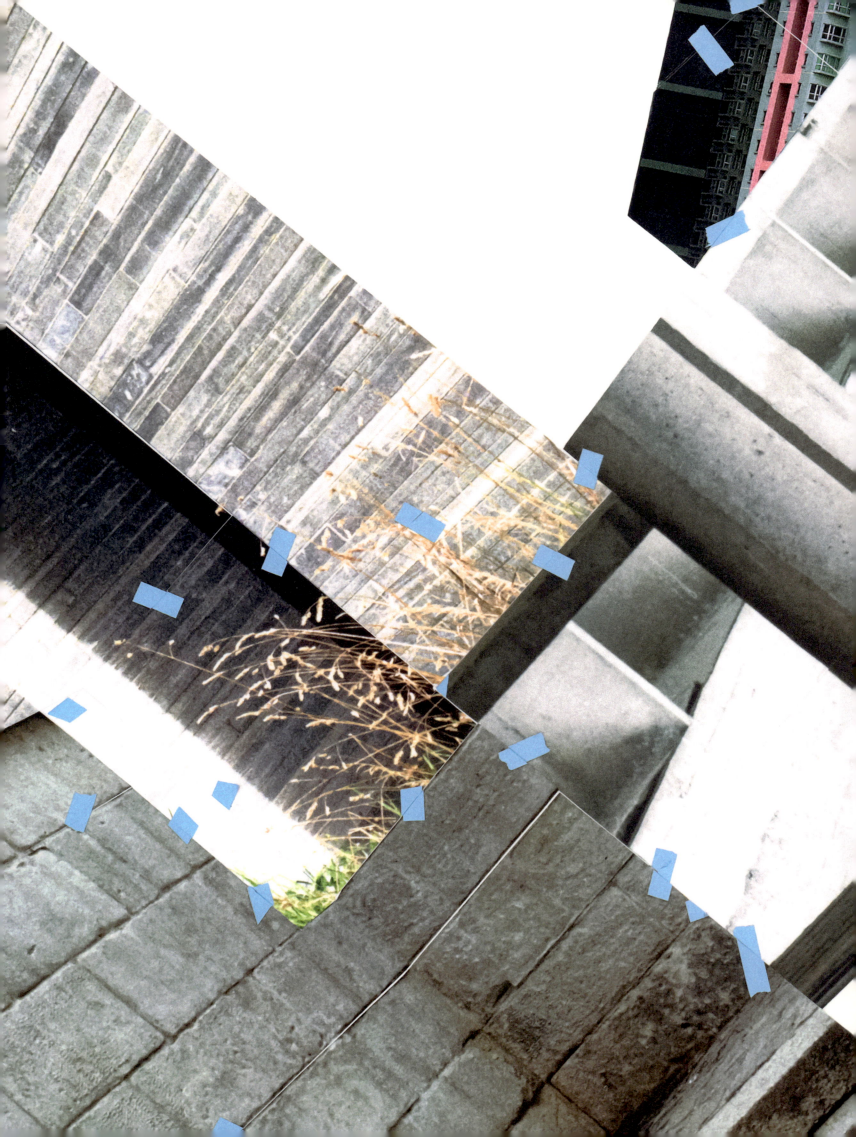

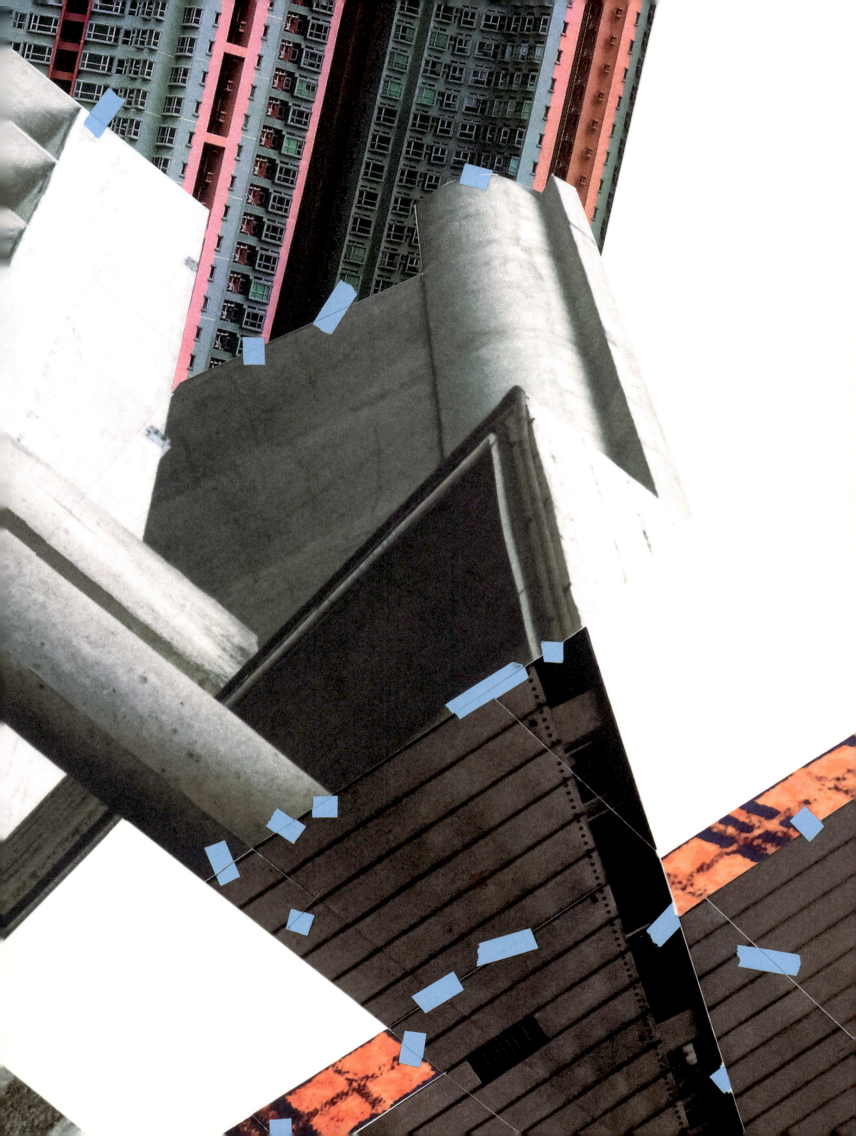

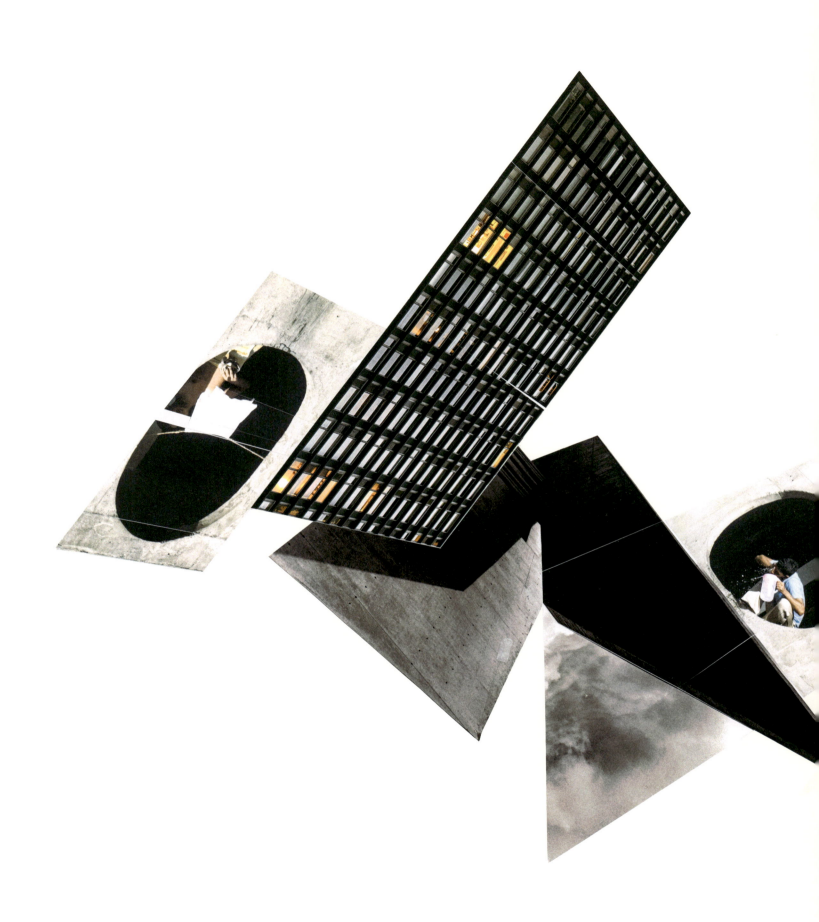

Prisoners on a Projecting Platform, 2021
Collage on archival paper, 38½ × 41 in.

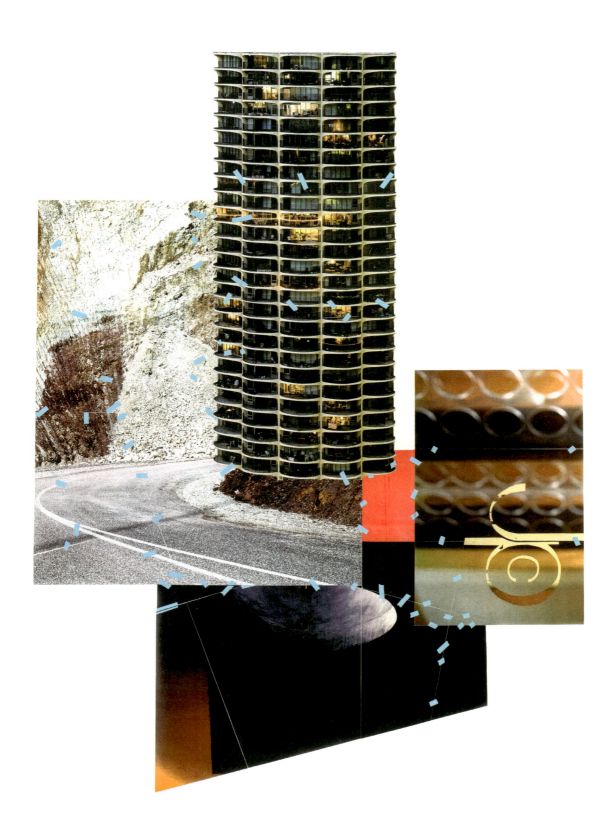

The Round Tower, 2021
Collage on archival paper, 44 × 33 in.

Block, Procession, Spin, & Map
James Glisson

For more than a century, collage has been a part of rendering architectural presentation drawings to share with the client and the public through exhibitions, magazines, or books. It has also been a means to break apart the structures of architecture—whether functionality, budget, or even gravity and space-time. Marshall Brown's collages sit within a long history, one too broad to survey here, but it is instructive to look at one prominent example. Ludwig Mies van der Rohe used the medium across his career. Looking at this paradigmatic modern architect shows that collage is often a way to not just picture structures that might be feasible but also to render spaces, shapes, and configurations that do not lead in an obvious way to a building. Mies's career is usually divided between his years in Germany, cut short by the Nazis, and his immigration to the United States in 1938. Dating from 1922, his photocollage for an unbuilt project of a skyscraper on Berlin's Friedrichstraße inserts a soft pencil rendering of the building into a photograph of the streetscape.

Ludwig Mies van der Rohe, entry 'Wabe' for the High-Rise Tower at Friedrichstraße Station Ideas competition, 1922 Reworked gelatin silver print. Bauhaus-Archiv Berlin, 8238 © 2022 Artists Rights Society (ARS), New York / VG Bild-Kunst, Bonn

Mies's clean crystalline forms play against the jumble of ornamented facades and sagging electrical wires to make the point about his sleek intervention in the eclectic streetscape of Berlin. Other Miesian collages, such as the study *Concert Hall project*, are not about a building; rather, they experiment with spatial problems and jarring contrasts without worrying about engineering.

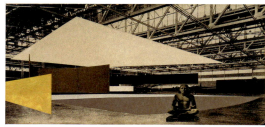

Ludwig Mies van der Rohe, *Concert Hall project (Interior perspective)*, 1942. Graphite, cut-and-pasted photo reproduction, cut-and-pasted papers, cut-and-pasted painted paper, and gouache on gelatin silver photograph mounted on board, 29½ × 62 in. The Museum of Modern Art, New York, Mies van der Rohe Archive, gift of Mrs. Mary Callery, 571.1963. © 2022 Artists Rights Society (ARS), New York / VG Bild-Kunst, Bonn. Digital Image © The Museum of Modern Art / Licensed by SCALA / Art Resource, NY

Here, an airplane factory has been broken up by floating colored sheets that upend scale and a consistent signaling of depth. The levitation of the sculpture removes a horizon line or a ground. The overlap of the sheets causes an ambiguous spatial relation that does not lead toward an obvious "solution" or blueprint for a structure. The exploratory collage works through the problem of filling in and activating a vast space uninterrupted by supports, an issue Mies returned to in the Neue Nationalgalerie commission in Berlin and the Cullinan Hall at the Museum of Fine Arts, Houston.

Other essayists in this catalogue and the artist himself talk about Brown's collages as a means to loosen up and discover, to escape the strictures of site, budget, architectural history, and client. This essay does the same, but moves in several other directions: one, arguing that these collages reveal characteristics of architecture so integral, so axiomatic, that they normally escape notice; two, showing that collages tap into and excite the cognitive processes of visualization and visual reasoning, in particular, the mental rotation of a shape; and three, revealing that collaged maps strike out in an entirely new area. These maps are less about architecture than about cartography's ability to convey meaning through conventions and about maps' potential for beauty as a pattern partially disconnected from the area of the Earth they represent. Put another way, Brown's collages give us the atoms of architecture—the sine qua nons of building and how it is experienced—and open the black box of spatial visualization in the mind. Four keywords help to unpack these ideas. Let's begin with the block.

BLOCK

In *14-07-27* [p. 29], at least three modernist buildings are pressed together. One is Marcel Breuer's Whitney Museum, another is by Coop Himmelb(l)au, and a third is an inverted building, possibly by Richard Meier. The three structures' surfaces are all divided into irregular grids. The collage shoves everything toward two parallel vertical axes: one the corner of the Himmelb(l)au building and the other articulated by the abrupt collision of Breuer's window and the negative space of the white paper. These corners stack into a pile, and their protruding and patterned facades emphasize the cubes and rectangular prisms—the repeated units that are the atoms of any building. Structural or decorative, solid or void, brick or thatch, adobe or titanium sheet, these units add up to a structure whose complexity is many orders of magnitude greater than the individual blocks.

Nothing for as Long as Possible [p. 82] takes the atomic unit, the block, and expands it into a three-dimensional lattice. This collage is replete with grids. First, there is the curtain wall of a Miesian skyscraper, a 3 × 3 grid with one window removed. These windows bleed into cloth drapery in a tastefully furnished mid-century modern living room with a view to a patio. Through the broad window, there are two trees, one with a thick trunk. Below, a network of scaffolding is being assembled. The trees and scaffolding strain to hold their respective canopies aloft, and they act as if they were mirror images of each other, linked by an obscure logic of form and function. Across the collage, closed and open spaces play off each other. The blinds in the skyscraper form a syncopated rhythm picked up in the living room by the drapes and the open window. This subliminal play of open and closed emphasizes each of the units whose combination is the basis for these structures. The scaffolding visualizes the 3D lattice that contains these units, and its rickety poles call to mind the hidden steel skeleton that supports the skyscraper. Put another way, the scaffolding is projected onto the rest of the collage, underlining the encased and invisible support structures.

While made of aluminum foam and supported by aluminum I beams rather than paper and glue, *Ziggurat*'s stacked and interpenetrating forms came out of collage *14-07-27* [p. 54]. Indeed, *Ziggurat* [p. 48] emerges from two grid-based systems: the stacked blocks that diminish in size toward the top, and the web of gaps between the aluminum foam panels. These two systems mesh to give more complexity and unpredictability than either one alone could do. This artwork has many historical precedents. In ancient Mesopotamia, ziggurats were stepped, clay-brick structures that narrowed at the top. Another antecedent is the folly, which includes the fake ruins, castle towers, and Greco-Roman revival temples of aristocratic eighteenth-century gardens, and Bernard Tschumi's deconstructed bright red beacons at Paris's Parc de la Villette. Follies are, as a genre, understood to flaunt convention and to present architecture outside of its functional role as shelter, storage, or monument. With its block units and resistance to categorization, *Ziggurat* is of a piece with the collages, but it also goes back to Brown's deep resistance to assumptions about architecture's presumed functionality.

Brown's *Prisons of Invention* reference Piranesi's *Carceri d'invenzione* [Imaginary Prisons]. While Brown's collages lack an Enlightenment-era dystopian sci-fi tenor, both artists depend on a modular system. Piranesi's blocks in the *Carceri* are heavy stones that are assembled into arches, staircases, and towers. He repeats, stacks, and rotates them in gradually smaller sizes as they go into the distance. Like a mathematician knowing that a function curves toward a limit without reaching it, the viewer infers that these units iterate ad infinitum toward a hidden vanishing point. Both Brown and Piranesi begin with units—whether photographs from magazines or stone blocks—that only take leave from the everyday expectations of architecture as they are repeated and combined. The units on their own are unremarkable, but placed together they multiply into something existing (for the time being) only as an image, an emanation of the architect's imagination.

PROCESSION

A Part, Not the Whole [p. 78] reads from left to right, starting with the travertine slabs of the peristyle of Louis Kahn's Kimbell Art Museum in Fort Worth, Texas. One follows the curved roof, then enters a courtyard, then another, then two expanses of stone walls. Each of these is a step through spaces and stone surfaces made contiguous by collage. This procession is not a frantic film montage of a dramatic moment, like a car chase or the hero confronting the villain, but rather a stately measured pace, much like the experience of Kahn's museum.

What is the significance of the collage's slowed-down movement through these virtual spaces? The experience of a building or built environment is time-bound to a far greater degree than painting or drawing, in which a motionless spectator can take in everything through darting eye movements and maybe a tilt of the head, or a few steps here or there. A building, even a small one, has sides, interiors, and different viewpoints from which it can be seen. These cannot be taken

in all at once. A standard reading of collage generally and photo collage specifically is that its disjunctions and juxtapositions disorient and therefore mirror the noisy, ever-moving panoply of the modern metropolis and the upheavals of life in a capitalist and industrialist world. Such a reading might be a promising interpretive avenue, but few of Brown's collages seem agitated. There is a calm about most of them. Moreover, he nearly always cuts out urban, natural, or other sorts of surrounding context. These collages appear less about modernity at large—cities, factories, subways, or sprawl—and more about architectural design, especially the unexpected affinities between buildings. They also reprogram the unthinking way that most of us pass through architecture without giving it much thought.

In *A Part, Not the Whole*, successive moments from successive photographs in the collage pull these buildings out of the uninterrupted flux of events. This is no small feat. Mostly, the experience of architecture is bound up with time and welded to what William James called the "stream of consciousness." The architectural spectator is mobile or imagines and projects mobility, conjuring how an unseen space might be navigated. One walks through a door, down a hall, up a flight of stairs, and back again. What Brown's collage accomplishes is to slow down, though not to freeze, movement. It is step-by-step, as if seen with a slide projector noisily clicking from picture to picture. The subtle cuts on the collage's surface do the work of inconspicuous commas between the photographs. The stream of consciousness flows on but is now divisible.

The idea of procession is related to the often-noted similarity between the time-bound way architecture presents itself and the experience of watching a film. A sequence of shots spliced together to make a film is called a *montage* and can be thought of as a time-based version of collage. Writing about the vistas and siting of temples on the Athenian Acropolis, Sergei Eisenstein in "Montage and Architecture" considered the relationship between film montage and the ancient archaeological site.[1] The filmgoer must sit still as the filmmaker propels the story forward through montage. Eisenstein pulled these two forms of art together by examining an archaeological analysis of the Acropolis, which argued that the buildings' asymmetrical and superficially illogical placement made sense only if they were meant to be seen by a person walking through the site, one who could see the different viewpoints and vistas. Architecture, unlike film, requires an ambulating spectator.

Some of Brown's collages, including *A Part, Not the Whole,* have a similarity to what Eisenstein describes. The shot-by-shot procession from peristyle to courtyard to courtyard to stone wall to another stone wall resembles Eisenstein's ramble across the Acropolis. The language of Brown's collages does more. While the collages' sequencing acts like a film, with the scenes moving from place to place, the attention is not on vistas, whole facades, allées, or parts of the same building or site. Brown's collages lack the strident political or narrative message that Eisenstein imparted through montage in films such as *Battleship Potemkin* (1925). Because there is no overall plot or ideological agenda, the textures, colors, and play of light on surfaces in the collages remain disaggregated rather than pulled into the flow of a narrative-driven montage. Discrete visual sensations in succession remain separated, and they cannot be added up like numbers in a column to give the sum of a building, location, story, or message. These sensuous instances, normally swept up in the stream of consciousness in which a building is apprehended, have been pulled apart and put on display.

14-09-11 [p. 37] illustrates the slowing down of the experience of architecture. The three groups of windows are blue, orange, and pink, and they reveal to some degree what is inside these sumptuous minimalist structures. In one, the blue gloam of evening mixes with the warm yellows of incandescent lights and throws furniture into profile. In another, orange signals, perhaps, warmth, domestic comfort, and enclosure. The diaphanous pinks and purples make up the last piece of this colored window trio. Each group of windows acts as a stopping point, with each color marking a different moment in time.

Another collage, *14-11-24* [p. 33], also disaggregates the experience of architecture into sensuous steps or stops. First, there are the panes of glass reflecting the orange sunlight of dawn or dusk. Jutting from the picture plane is a plank for a bench or low barrier counterpoised to a wall of smoothly finished cement. At the top, sunlight hits a paneled surface. Still another example can be seen in *14-07-15* [p. 28]. Two building facades are stacked on top of each other, then an orange roof structure, and finally a stone wall photographed in black and white with the sun reflecting back. The collage resolves into four zones of color, and the two facades read a bit like roughly textured surfaces.

SPIN

If *block* describes the atoms and armature that underlie architecture, and *procession* unlocks the sensual experience of a building pulled from the flux, then *spin* turns to the architect's mental tool kit and their visualization. Take *14-09-23* [p. 39] and follow its

[1] Sergei M. Eisenstein, intro. Yve-Alain Bois, trans. Michael Glenny, "Montage and Architecture," Assemblage no. 10 (Dec. 1989), 110–131.

2 Barbara Tversky, *Mind in Motion: How Action Shapes Thought* (New York: Basic Books, 2019), 94–106, and 262–69.

3 For a study of urban growth and fractal geometry, see Michael Batty, *Cities and Complexity* (Cambridge, MA: MIT Press, 2005); and Geoffrey West, *Scale* (New York: Penguin Books, 2017), esp. 288–95.

4 For a review of studies on this phenomenon, see Arne D. Ekstrom, Hugo J. Spiers, Véronique D. Bohbot, and R. Shayna Rosenbaum, *Human Spatial Navigation* (Princeton: Princeton University Press, 2018), 36–37 and 75–76.

progression from left to right. The panel partially obscures a view into an enclosure that is flanked by a tree trunk stripped of branches but covered in bark. Next to that is a length of gray siding with a cross attached. Then the collage's orientation flips 90 degrees, and wooden-framed windows with roof beams protrude to the right margin. With a mere turn, *14-09-23* manages to toss off architecture's requirement to resist gravity. Although it has a fixed orientation for display and reproduction, the collage wants to rotate as the mind tries to find the ground, like a cellphone screen tipping back and forth from vertical to horizontal.

In *Error as Hidden Intention* [p. 70], a set of bricked arches abuts a cast concrete structure with a deeply shadowed overhang. Beyond or above the overhang are the triangular skylights of I. M. Pei's East Building of the National Gallery of Art in Washington, DC. While the initial impression is that the view is straight up into the skylights, the photography is a horizontal view across the wing toward an opening and stairwell that are upside down.

The many collages that spin transform buildings into weightless components, bobbing helium balloons to be flipped, twisted, combined, and broken apart. There is no place to stand, and while there is a progression from point to point, one cannot envision a body moving through them. They show something possible in the collage but impossible elsewhere. Other essayists in this catalogue have thought about Brown's collage as a means to break down, or at least upset, the constraints imposed by laws, budget, site, materials, the limits of engineering, and the canons of architectural history. All of the collages do all that, but those that spin also excite the faculty of mental visualization. In *Mind in Motion*, psychologist Barbara Tversky summarizes the extensive research on mental rotation tests.[2] She concludes that although there is an innate facility for some test subjects, training improves this skill. Her research group has also conducted studies on architects at work by filming them drawing to solve a design problem. The psychologists then followed up with interviews to understand more about the process. She concluded that seasoned architects, unlike recent graduates, had a far greater ability to take a sketch's ambiguity and then project or imagine what was not already present on the paper. Put another way, they could use a messy sketch to imagine another line, plane, or connection not yet materialized on the page.

The mental rotations sparked by these collages work like those sketches because they prompt the mind to see what is not there, to rearrange elements, to unglue a piece of paper and shift it elsewhere. While the collages are finished artworks, they invite completion by moving elements around mentally—yet this never yields completion or a whole or a satisfactory resolution. Instead, and this is what is so compelling about the spin, we are held in a place of permanent exploration, of a finished and polished tentativeness and instability, one that mirrors the design process but stops it from coming to rest.

MAP

The keywords *block*, *procession*, and *spin* have hopefully revealed how Brown's collages bring to the surface the deepest patterns that govern the construction, experience, and design of buildings. The keyword of this final section is straightforward. In the summer of 2021, while in Berlin, the artist began to work with technical survey maps that include information on building types, open areas, agricultural zones, and transportation routes (canals, roads, or rail). Brown reveals the beauty of these maps by cutting them up and reattaching them so that their colored networks of roads, rivers, and buildings run into one another. This aesthetic of nonalignment is quietly underscored by the overall grid arrangement that he imposes. *Piranesian Map of Berlin, ca. 1986* [foldout at p. 65] is modular, made of parts that can be disassembled. This orthogonal overlay makes it easier to appreciate the meandering and gently pleasing growth patterns of a built environment that developed over centuries in response to rivers and topography, which then mixed with the order imposed by the Hobrecht Plan of 1862. These fractal urban-growth patterns are like the craquelure of a weathered wall.[3] They are much more noticeable when contrasted with the straight lines, cuts, and seams of Brown's map.

These collaged maps force a reckoning with the graphic conventions that underpin a map's orderly conveyance of information. In *Piranesian Map of Berlin, ca. 1986*, the eye roves over the nine units, searching for familiar geographic outlines or names. One can spot Berlin's Flughafen Tempelhof, though upside down, and another section contains the Spree's distinctive sinuosity. Despite moments when landmarks can be located, the maps scramble orientation. Is this north or south? Psychologists studying human navigation have observed that wayfinding is substantially impaired when a test subject cannot orient to the north.[4] (This is probably due to the widespread use of maps.) The jamming of signals happens on other levels. What about the color white, which sometimes stands for roads but also for buildings and open areas? Compounding this misalignment, there is in the upper right corner a color key for a 1986 map of Berlin that cannot relate to all the

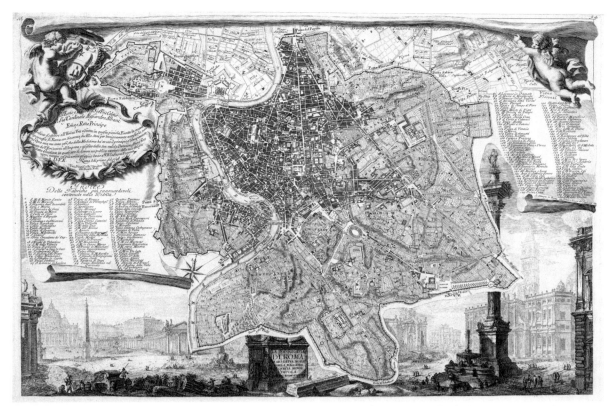

Giovanni Battista Nolli and Giovanni Battista Piranesi, *Plan of Rome, reduced from the large Nolli plan on numerous sheets, with various views below*, 1748. Etching, 26¾ × 18¼ in. British Museum, London, 1886, 1124.196
© The Trustees of the British Museum

5 Richard Wollheim, "Seeing-as, Seeing-in, and Pictorial Representation," in *Art and Its Objects*, 2nd ed. (Cambridge: Cambridge University Press, 1980), esp. 217–24. Michael Podro explicates and expands Wollheim's distinction; see *Depiction* (New Haven: Yale University Press, 1998), 5–8.

6 These are but a few examples of Piranesi's efforts; see Joseph Connors, *Piranesi and the Campus Martius: The Missing Corso; Topography and Archaeology in Eighteenth-Century Rome* (Rome: Unione Internazionale degli Istituti di Archeologia Storia e Storia dell'arte in Roma, 2011), 29–31.

7 Heather Hyde Minor, *Piranesi's Lost Words* (University Park: Pennsylvania State University Press, 2015), 114.

maps in the collage. The hues of pink, green, soft gray, and bright cyan have been partially freed from their role as guides. Instead, they resolve into intricate patterns that elegantly jostle together like a Persian miniature painting or the decorations of medieval manuscripts. While still a map *of* Berlin, they also register as patterns. This duality mirrors a distinction that Richard Wollheim has applied to paintings. For Wollheim, a painting has "twofoldness": one, a series of marks on a surface; and two, the image that these marks create in the mind as a person looks. One can admire how the deft brushwork resolves into foliage or a well-placed smattering of white is also a highlight on a bowl. These two ways of looking weave together constantly when viewing a painting, and they are not layers or separate moments.[5] In an analogous way, Brown's cuts and juxtapositions emphasize the maps as configurations of lines, colors, and shapes, yet these maps also depict Berlin. In the same way one might take in the "rightness" of the configuration of a painter's brushwork, so too can one appreciate colors, patterns, and elegant systems for representing the built environment.

Like the *Prisons of Invention*, the *Piranesian Map of Berlin, ca. 1986* taps into the peculiar paradoxes that run through Giovanni Battista Piranesi's expansive oeuvre of etchings, illustrated books, writings, and maps. Piranesi made maps in collaboration with the surveyor and cartographer Giambattista Nolli. Piranesi assiduously studied the remains of ancient Roman architecture, reportedly climbing into cellars to examine foundations, dispatching children to crawl into underground spaces too tight for him, or speaking to workmen who had dismantled ruins. He also pored over ancient writers, seeking clues about structures that were lost or hidden by centuries of debris.[6] This research, archaeological and literary, informed his etchings of monuments, maps, architectural details, and the *Carceri*—in other words, nearly everything he did over an astoundingly prolific career.

Both Piranesi and Brown take maps as forums for dreaming and imagining, sheets of paper transformed by the artist's willful intervention. Neither, however, creates maps of mythical realms, alien planets, or an Earth centuries hence. Their dreaming is circumscribed by history and its manifestation in the built environment. Indeed, Heather Hyde Minor has shown that "creativity and erudition happily commingled" in Piranesi's illustrations and maps of the ancient Roman area called the Campus Martius.[7] While Piranesi used a marble ancient map of Rome, *Forma Urbis Romae* (ca. 205–208 CE), to reconstruct this lost part of the city, his printed reproductions show many deviations and additions to structures included in the original map. Piranesi's huge map of his imaginatively reconstructed Campus Martius, with its rough faux-stone edges and the broken-off chunk in the upper corner, is based on the ancient prototype. The ancient map is an ichnographic or plan view at 1:240 scale and contains all the buildings of Rome. Individual rooms, passages, and entryways are recorded.

[8] Hyde Minor, *Piranesi's Lost Words*, 99.

Because very few structures in Piranesi's reconstructed map existed in eighteenth-century Rome, they could only be known through ancient writers, such as Strabo, who recounted the wonders of Imperial Rome.[8] Although both artists' maps are formed from a mosaic of sources, they function differently. Piranesi seeks reconstruction and imaginative synthesis, while Brown keeps the pieces and their seams in play. With his etchings and maps, Piranesi reanimates an ancient city and culture partially lost to history, while Brown emphasizes their millefiori designs and pries them away from the cartographic information they represent.

Nolli and Piranesi's *Plan of Rome* (1748) has no cuts, but it shares the logic of a collage. At the top, the thickly engraved lines emphasize the shadow of the curling paper that pulls up at the bottom, as if the map has been tightly rolled up. In Brown's maps, the loosely affixed keys mimic this illusion. Also, in the earlier map, there is a cut, albeit not made with scissors. It follows the contour of the Aurelian Walls and bumps into scenes of Rome's monuments: Saint Peter's Square on one side, and a view of Trevi Fountain, Santa Croce in Gerusalemme, and Santa Maria Maggiore on the other.

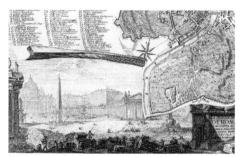

Nolli and Piranesi, *Plan of Rome* (detail), 1748

While the earlier map is only one sheet of paper, Brown's decision to allow the key in *Piranesian Map of Berlin, ca. 1986* to flap, as if curling or lifted by a slight breeze, is a reminder that Piranesi's map is collage avant la lettre.

As this essay has argued, using keywords as guideposts, Brown's architectural collages probe the deepest structuring principles of architecture and its experience. The maps do something similar for cartography. Modern cartography orients maps to a consistent direction, normally to the north. They adhere to a scale and a keyed set of colors. Brown upends these rules with his mixing. The collages and maps share another affinity: they contain pieces of the actual world—photographs of existing structures and maps of Berlin—yet those parts, when put together, take leave of the actual. These collages are not pure fantasy. We can see them. They hang on a wall. Moreover, their forms and ideas might in the fullness of time loop back to this world, the one we all live in, with its gravity, budgets, and vexations.

List of Plates*

Chimera

13-12-31, 2013*
Collaged magazine pages,
glue on archival paper,
14 × 17 in.
Santa Barbara Museum of Art
Museum purchase with funds provided
by the General Art Acquisition Fund,
2022.8.6

14-09-02, 2014
Collaged magazine pages,
glue on archival paper,
17 × 14 in.

14-11-24, 2014*
Collaged magazine pages,
glue on archival paper,
17 × 14 in.
Santa Barbara Museum of Art
Museum purchase with funds provided
by the General Art Acquisition Fund,
2022.8.4

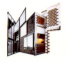
14-03-27, 2014
Collaged magazine pages,
glue on archival paper,
17 × 14 in.

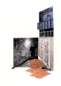
14-07-15, 2014
Collaged magazine pages,
glue on archival paper,
17 × 14 in.
Private collection, Chicago, IL

14-03-10, 2014
Collaged magazine pages,
glue on archival paper,
17 × 14 in.
Collection of Conor O'Neil, Chicago, IL

14-03-21, 2014
Collaged magazine pages,
glue on archival paper,
17 × 14 in.

14-07-27, 2014*
Collaged magazine pages,
glue on archival paper,
17 × 14 in.
Museum of Contemporary Photography
at Columbia College Chicago
Museum purchase, 2018:8

14-12-30, 2014
Collaged magazine pages,
glue on archival paper,
17 × 14 in.

14-05-21, 2014
Collaged magazine pages,
glue on archival paper,
17 × 14 in.

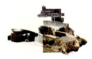
14-04-07, 2014*
Collaged magazine pages,
glue on archival paper,
14 × 17 in.

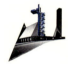
14-05-10, 2014
Collaged magazine pages,
glue on archival paper,
17 × 14 in.
Museum of Contemporary Photography
at Columbia College Chicago
Museum purchase, 2018:7

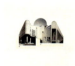
14-03-20, 2014
Collaged magazine pages,
glue on archival paper,
17 × 14 in.
Collection of the University Club of
Chicago, Chicago, IL

14-12-17 (2), 2014
Collaged magazine pages,
glue on archival paper,
14 × 17 in.

14-09-11, 2014
Collaged magazine pages,
glue on archival paper,
17 × 14 in.
Collection of Suzette Bross, Chicago, IL

14-08-30 (2), 2014
Collaged magazine pages,
glue on archival paper,
17 × 14 in.

14-12-26 (3), 2014*
Collaged magazine pages,
glue on archival paper,
17 × 14 in.
Museum of Contemporary Photography
at Columbia College Chicago
Gift of the artist and Western Exhibitions,
Chicago, 2018:6

14-09-23, 2014*
Collaged magazine pages,
glue on archival paper,
17 × 14 in.
Santa Barbara Museum of Art
Museum purchase with funds provided
by the General Art Acquisition Fund,
2022.8.5

Ziggurat

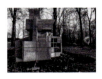
Ziggurat, 2016
Alusion foamed aluminum panels, wood structure,
and aluminum I beam base, 122 × 144 × 96 in.
Crystal Bridges Museum of American Art, Bentonville, AR
Made possible by Chauncey and Marion Deering McCormick Foundation, 2018.14

Maps of Berlin

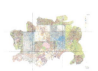
*Piranesian Map of Berlin,
ca. 1986*, 2022*
Collage on gessoed board,
72 × 108 in.

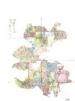
*Piranesian Map of Berlin,
ca. 1800–1690*, 2022*
Collage on gessoed board,
96 × 72 in.

Je est un autre

We Need Holes, 2019
Collage on archival paper,
13 × 10 in.

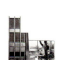
Repetition as a Form of Change, 2019*
Collage on archival paper,
23½ × 18 in.

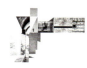
A Part, Not the Whole, 2019
Collage on archival paper,
18 × 23½ in.
The Art Institute of Chicago Purchased with funds provided by The Chauncey and Marion D. McCormick Foundation, 2020.16

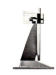
Toward the Insignificant, 2019*
Collage on archival paper,
23½ × 18 in.
The Art Institute of Chicago Purchased with funds provided by The Chauncey and Marion D. McCormick Foundation, 2020.17

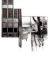
Nothing for as Long as Possible, 2019*
Collage on archival paper,
23½ × 18 in.
Santa Barbara Museum of Art Museum purchase with funds provided by the General Art Acquisition Fund, 2022.8.3

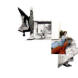
A Choice to Do Both, 2019*
Collage on archival paper,
23½ × 18 in.

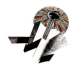
The Thing Most Easily Forgotten, 2019
Collage on archival paper,
10 × 13 in.
Private collection

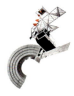
Error as Hidden Intention, 2019
Collage on archival paper,
13 × 10 in.
Private Collection, New York, NY

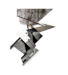
Accretion, 2019*
Collage on archival paper,
18 × 23½ in.
The Art Institute of Chicago Purchased with funds provided by The Chauncey and Marion D. McCormick Foundation, 2020.15

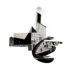
The Principle of Inconsistency, 2019*
Collage on archival paper,
17¾ × 23⅜ in.
Collection of Sharon Bautista

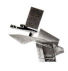
Easement, 2019*
Collage on archival paper,
23½ × 18 in.
Santa Barbara Museum of Art Museum purchase with funds provided by the General Art Acquisition Fund, 2022.8.2

Prisons of Invention

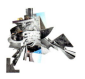
Pantheon, 2020*
Collage on archival paper,
43 × 45 in.
Santa Barbara Museum of Art Museum purchase with funds provided by the General Art Acquisition Fund, 2022.8.1

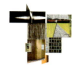
The Smoking Fire, 2021*
Collage on archival paper,
36 × 36 in.

The Gothic Arch, 2021*
Collage on archival paper,
45 × 33 in.

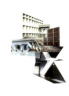
The Well, 2021
Collage on archival paper,
45 × 36 in.

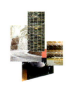
The Round Tower, 2021*
Collage on archival paper,
44 × 33 in.

The Drawbridge, 2021*
Collage on archival paper,
36½ × 36½ in.

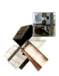
The Staircase with Trophies, 2021*
Collage on archival paper,
45 × 32½ in.

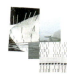
The Grand Piazza, 2021*
Collage on archival paper,
44¾ × 36 in.

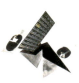
Prisoners on a Projecting Platform, 2021
Collage on archival paper,
38½ × 41 in.

*Indicates artwork displayed in *The Architecture of Collage: Marshall Brown*, October 2, 2022–January 7, 2023, Santa Barbara Museum of Art. Unless otherwise indicated, all works are courtesy of the artist and Western Exhibitions, Chicago, IL.

This catalogue is made possible
by the generosity of

Susan D. Bowey

The Museum Collectors' Council
of the Santa Barbara Museum of Art

Barr Ferree Foundation Fund for Publications
Department of Art and Archaeology
Princeton University

**Graham
Foundation**

Acknowledgments

Thank you to Yvonne and Mia for love, encouragement, and connection. Thank you to my parents for providing me with tools to take things apart and put them back together. I owe a creative debt to Sheldon Helfman, who taught the freshman design studio at Washington University in 1991 and was responsible for my first serious introduction to collage. I am grateful for Scott Speh at Western Exhibitions, who saw the artistry in my work and has provided me with space to transgress the imagined boundaries of architecture. Thank you, Janine Mileaf, Executive Director of the Arts Club of Chicago, who commissioned *Ziggurat*, which was also generously supported on multiple fronts by the Chauncey and Marion Deering McCormick Foundation. Aaron Betsky and Anna Arabindan-Kesson have provided their brilliant insights to this project, for which I am indebted to each of them. I am also very fortunate for James Glisson's interest, guidance, and stewardship of this project with, of course, support from the Santa Barbara Museum of Art.

Marshall Brown

I wish to thank all the people who have made this catalogue and exhibition possible. There would be no project at all were it not for Marshall Brown, his art, and writing. He has a clear vision and is a generous collaborator. Working on this project with him has been a pleasure. At every turn, he proposed brilliant solutions to questions, and he knows how to inspire a team. I hope he is happy with the outcome. I certainly am. Aaron Betsky and Anna Arabindan-Kesson wrote brilliant interpretive essays on a tight timeline. Lisa Schons and Chris Reding at Park Books of Zurich took on the project with an equally short timeline and have been solid partners throughout. With her restrained sensibility, catalogue designer Sandra Doeller has done a marvelous job. Scott Speh at Western Exhibitions located items for loan. Many colleagues at other museums have contributed to this project: Alison Fisher and Matthew S. Witkovsky, Art Institute of Chicago; Austen Barron Bailly, Alejo Benedetti, Miquel Geller, and Victor Gomez, Crystal Bridges Museum of American Art; Silvia Perea and Gabriel Ritter, Art, Design & Architecture Museum, UCSB; and Laura Santoyo, Natasha Egan, and Kristin Taylor, Museum of Contemporary Photography, Columbia College, Chicago.

The entire staff at the Santa Barbara Museum of Art has come together to share Marshall's art with the public. Larry J. Feinberg, Robert and Mercedes Eichholz Director and CEO, immediately understood the importance of Marshall's work and has supported this project from the start. In the Director's Office, Tracy Owens and Jeanne Bacsi manage the Museum's nerve center. In Development, Karen Kawaguchi, Wendy Darling, Susan Bradley, Melissa Chatfield, and Molly Kemper located the resources to make this project happen. As Curatorial Assistant, Lauren Karazija contributed to every part of this project with enthusiasm. Allyson Healey turned her keen eye on the catalogue. The Registration and Facilities staff, once again, have pulled off a beautifully installed project, with special thanks to Mary Albert, John Coplin, Malina Graves, Tom Pazderka, Paul Swenson, and John Walbridge, and most especially to Kelsey McGinnis and Phil Lord. In Finance, Diane Lyytikainen, Lisa Lenvik, and Kristi Ruiz have been efficient as always. In Education, Patsy Hicks, Kristy Thomas, and Rachel Heidenry embraced the project and have executed astounding programming. In Communications, Katrina Carl and Dune Alford made sure to get the word out through every channel. In Visitor Services, Brittany Sundberg, Vida Alvarez Thacker, and Simon Solberg welcomed the public. The Security Department is integral to the Museum's work with the public, and I want to acknowledge each of them by name: Emma Bobro, Joe Buchanan, Tatiana Rodriguez, Marc Alvarez, Richard Montejano, Gregory Freeman, Jack Page, James Walter, Juan Fuentes, Ivan Serratos, Gary Baxter, Roger Balabanow, Steve Boyajian, Charles Burggraf, Warren Burleson, Rod Edwards, Bill Aikele, Tobias Burress, Cameron Lenvik, Kevin Nava, Miguel Morales, Mike Woxell, and Huber Guadarrama, Jr. In the Museum Store, Amy Davidson and Janet Takara have thoughtfully merchandized around the exhibition. In IT, Joe Price and Brock Odle kept us connected. My fellow curators, Eik Kahng, Susan Tai, and Charles Wylie, have been supportive throughout. Zirwat Chowdhury offered timely advice.

James Glisson
March 2022

Published on the occasion of the exhibition *The Architecture of Collage: Marshall Brown* at the Santa Barbara Museum of Art, October 2, 2022–January 7, 2023

The Architecture of Collage: Marshall Brown is organized by James Glisson, Curator of Contemporary Art, Santa Barbara Museum of Art, and Marshall Brown.

Editor:
James Glisson

Copyeditor:
Keonaona Peterson

Proofreader:
Colette Forder
Jean Patterson

Production manager:
Chris Reding
Lisa Schons

Designer:
Bureau Sandra Doeller

Pre-press image editing:
DZA Druckerei zu Altenburg GmbH, Thuringia

Printing and binding:
DZA Druckerei zu Altenburg GmbH, Thuringia

Unless otherwise indicated in the captions, all images are artworks by Marshall Brown. All photographs of artworks by Marshall Brown are © Marshall Brown Projects and were provided by the artist or Western Exhibitions, Chicago, IL. Measurements are in inches, given with height first, followed by width and depth.

© Santa Barbara Museum of Art
© 2022 Park Books AG, Zurich
Texts © the authors
Illustrations © see image captions
Works by Marshall Brown
© Marshall Brown Projects

All rights reserved; no part of this publication may be reproduced, stored in a retrieval system or transmitted in any form or by any means, electronic, mechanical, photocopying, recording, or otherwise, without the prior written consent of the publisher.

First printing 2022
Printed in Germany

ISBN 978-3-03860-291-0

Santa Barbara Museum of Art
1130 State Street
Santa Barbara, CA 93101
United States
www.sbma.net

in association with

Park Books
Niederdorfstrasse 54
8001 Zurich
Switzerland
www.park-books.com

Park Books is being supported by the Federal Office of Culture with a general subsidy for the years 2021–2024.